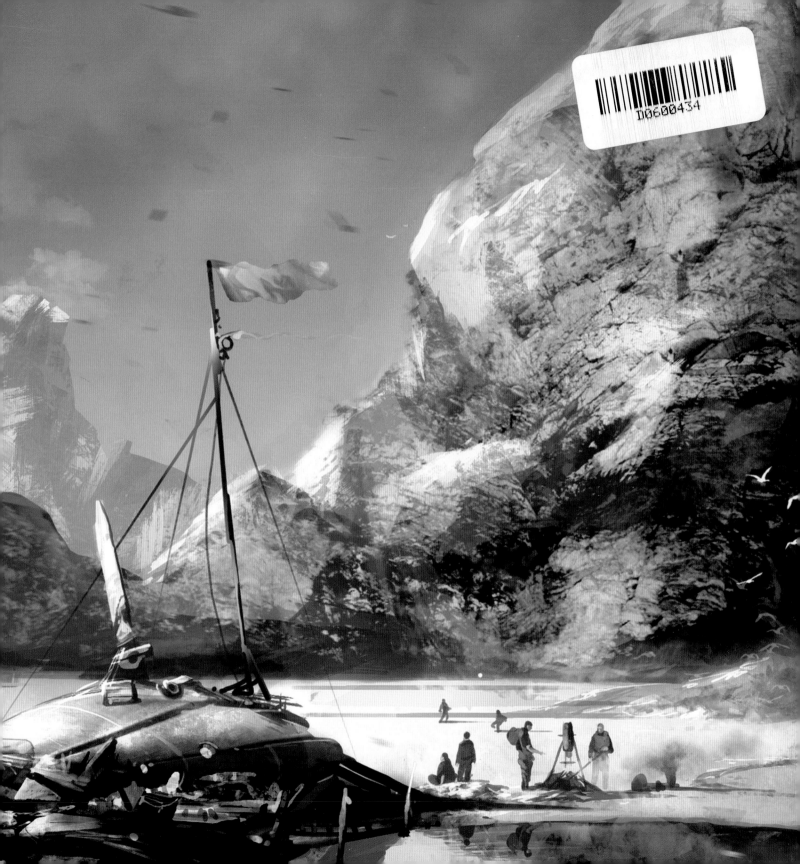

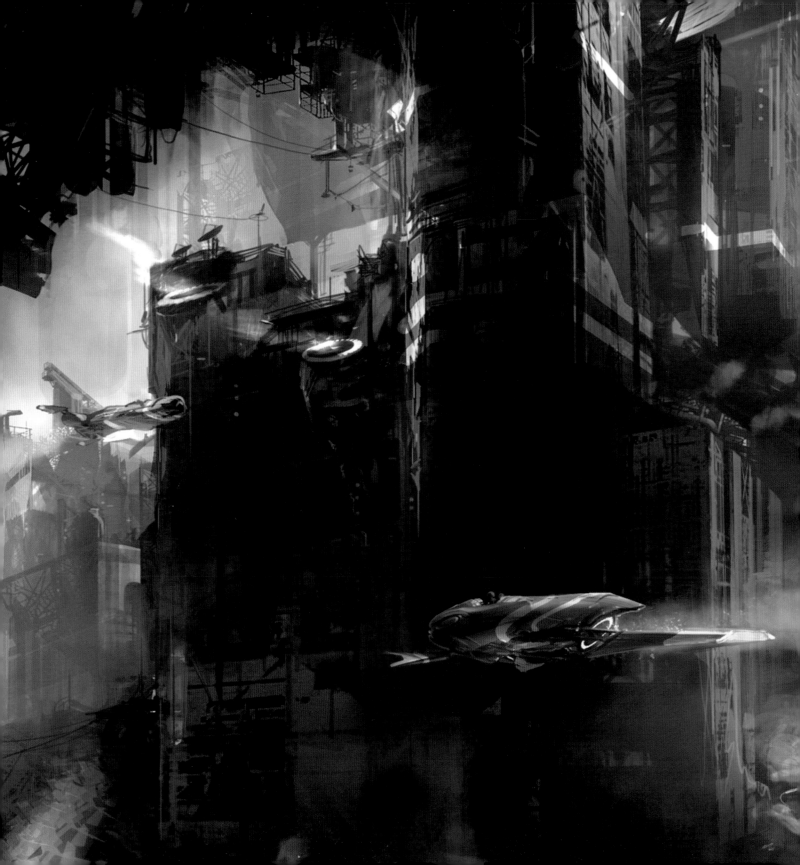

structura

the art of sparth

designstudio|PRESS

dedication

This book is dedicated to my wonderful wife Lorene, and my two sons Arthur and Leopold. They're the ones who transformed my universe forever.

"Maintenant tout est possible."
"Now everything's possible."

Contact info:

www.sparth.com

FSC Mixed Sources
Product group from well-managed forests, and other controlled sources
www.fsc.org Cert no. SGS-COC-003563
© 1996 Forest Stewardship Council

Published by
Design Studio Press
8577 Higuera Street
Culver City, CA 90232

Web site: www.designstudiopress.com
E-mail: info@designstudiopress.com

Printed in Korea
First edition, March 2008

10 9 8 7 6 5 4 3 2

Hardcover ISBN-10: 1-933492-26-0
Hardcover ISBN-13: 978-1-933492-26-1
Paperback ISBN-10: 1-933492-25-2
Paperback ISBN-13: 978-1-933492-25-4

LCCN: 2007943820

Sparth (nicolas bouvier) has been an active artistic director and concept designer in the gaming industry since 1996. Born in France, he now lives in Seattle, Washington, working for Microsoft.

Having had the privilege of traveling extensively at an early age to such places as far afield as the U.S.A., Singapore, China, France and Europe, he was influenced greatly by these various cultures, and he enjoyed observing people and making notes of all these tiny details of life that he was witnessing. These varied influences are largely responsible for his multiple creative passions, which range from space, to buildings, to robotics and beyond.

There are no limits to his creativity when it comes to translating forms and concepts. One of his greatest passions remains contemporary architecture, of which he applies principles in his own art, with an experimental and original approach. He also harbors a fascination for modern skyscrapers, although he admits that he wouldn't be able to live too high above the ground himself.

Sparth has contributed to the development of several major games since 1997, including Alone in the Dark 4 (2001), Prince of Persia - Warrior Within (2004), Cold Fear (2005), and Assassin's Creed (2007). Through Darkworks-Studio, he collaborated In 2003, he decided to leave Paris for Montreal in order to join Ubisoft. He then worked for IDsoftware in Dallas TX, from 2005 to 2008. In January 2009, he relocated to Seattle where he'll be working on the Halo franchise.

In recent years, Sparth has also enjoyed illustrating book covers. His images have adorned the novels of multiple French and English authors.

When he is not working, he finds time to relax with his wife Lorene and his three children, Arthur, Leopold and Zelie.

awards:

2006 - Expose 4 - Master award winner category science fiction.
2005 - Nominee for The 2005 Game Developers Choice Awards,
 category "Character Design", for the works on Prince Of Persia: Warrior Within.
2006 - Selected for the "into the pixel" 2006 Collection.

games:

Alone in the Dark 4 - 2001
Cold Fear - 2005
Prince of Persia: Warrior Within - 2004
Assassin's Creed - 2007

foreword

I love opening up emails from the future.

I love seeing an attachment in my mail, and knowing that when I click on it, I'm going to get yanked out of my basement office and transported to another world, another time, another place. I love that I'm going to get a few moments of basking in cool, tingling in awe, shivering with, dare I say it, sensawunder.

Whether he's sending me a cover illustration for something from my own book line, or sharing concept art for the latest computer game, I know Sparth is sending me a ticket right out of the here and now to the realm of might be, could be, should be.

The noted genre critic John Clute says that science fiction "accustoms us to looking; it does not, in the end, tell us what we are going to have to see. SF is the window, not the view." He means by this that the act of seeing beyond the ordinary is of value in and of itself, apart from any accurate prognostications about future technologies. Science fiction has always been the literature of change and wonder, the window that lifts us out of ourselves and shows us infinite possibilities. And from the earliest days of the genre, science fiction (and its sister fantasy) have been uniquely blessed to have partners charting the imagination in the persons of fabulous illustrators and artists who take us to landscapes which our own eyes fail to see.

These days science fiction is everywhere, having leaped out of books into television, movies, music and games. It's even leaked into our "real world" present, in the technology that surround us, penetrates us and binds the world together. It's in the iPod in my pocket and the BlueTooth in my phone. Which makes those who deal in the future as their stock in trade our most relevant visionaries.

When I look at the worlds conjured by Sparth's compelling imagery, I remember the sense of wonderment that drew me to genre fiction in the first place. His graceful airships and towering structures, insectoid robots and futuristic vistas are snapshots from worlds we would all of us live in if I could. More that that, they literalize the notion that the future is still worth believing in, fighting for, and even creating, by sowing the seeds of imagination right here in the present.

Yesterday, a dear old friend called me to ask, "Have you heard about this incredible new game, Assassin's Creed?"

"Not only have I heard about it," I said, "One of the Senior Concept Designers is a friend of mine."

"I'm not surprised," my buddy said. "It's totally cutting edge. Revolutionary. It's the future."

So is the book you hold in your hands. Open the window and take a look.

Lou Anders

Editorial Director, Art Director
Pyr, an Imprint of Prometheus Books
www.pyrsf.com

Being an artist is all about accepting permanent changes in one's art and techniques. Especially since the digital era took over a large part of today's creative industry. I remember starting my very first project in the professional world with a pencil in one hand, and a sheet of paper in the other. Like anyone else, I thought this situation was never going to end, or at least I could never have imagined that the digital era would become so mature in just a decade.

It took me some time to understand that the digital field, although extremely connected to traditional media, also had a life of its own, with techniques not found elsewhere, and a specific artistic growing microcosm defining the new genres with the help of a constantly evolving technology. I slowly got attached to that microcosm, which grew bigger year after year, to the point where I started wondering if perhaps I were becoming a digital artist instead of simply being an artist. Today I strongly believe this issue is no longer a question of interest. It is the pleasure of inventing and translating new shapes that prevails, as well as this marvelous feeling of freedom coming from this unique process.

I would be incapable of affirming that we become artists at birth. Receiving an empirical artistic knowledge is a rather odd belief. I rather think that it comes from a conjunction of multiple significant events, starting at a very early age. Events striking enough to give us the will to grab a brush and paint. As it is often said, becoming a better artist is generally done by meeting the right people, at the right time and at the right place. Inspiration often comes from our different encounters with people, but also from the discovery of new landscapes and sounds, and above all other matters we must train our senses permanently to the New and the Intriguing.

Thanks to my parents, I was able to travel a lot at a very early age, spending a large part of my youth abroad and pretty far from where I was born. Today I try doing the same with my own kids...not that I want them to forget about their roots, but knowing where you come from is today not enough.

I suppose this fact contributed to the particular attention I have always given to the universe of shapes: architecture, color usage, local traditions, sonorities, as well as the atmospheres intrinsic to any city. Indeed the distinctions are immense between Paris and Beijing, between Kuala Lumpur and Miami. And knowing how to observe these differences is without a doubt the best way to allow passions to grow within oneself. A bit like forging the keys necessary to the foundation of our personal and unique artistic expression: It can be done only by inexorably training and sharpening our senses to the world and its mechanism, by depicting the way light, shapes, and colors interact...a dedication of a lifetime.

sparth

Dallas, Texas
fall 2007

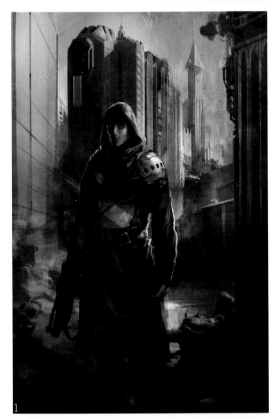

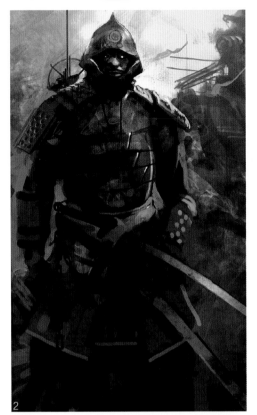

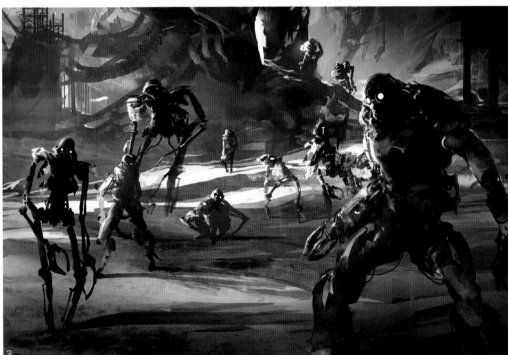

1 Changeling - Robert Zelazny - 2005 - book cover

2 Samuskell - personal work - 2004

3 Robotic Masks - Philip K. Dick short stories (extract) - 2006

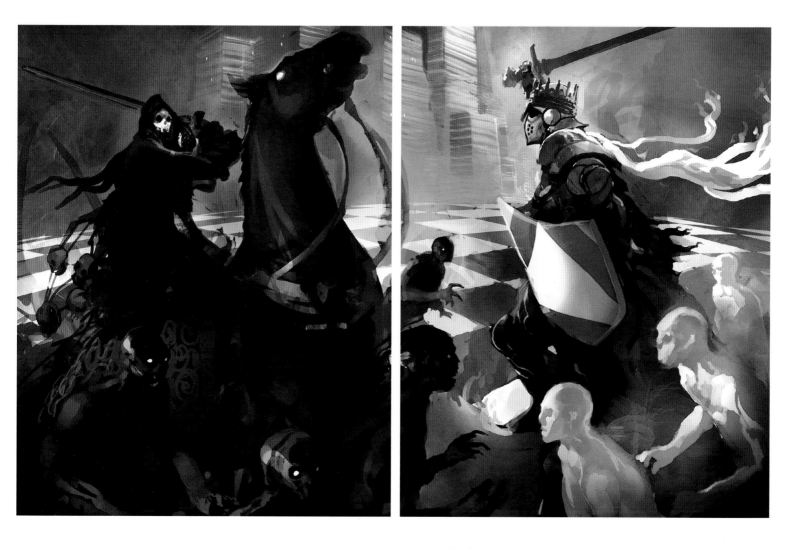

Carrion Comfort, part 1 & 2 - Dan Simmons - 2003 book covers

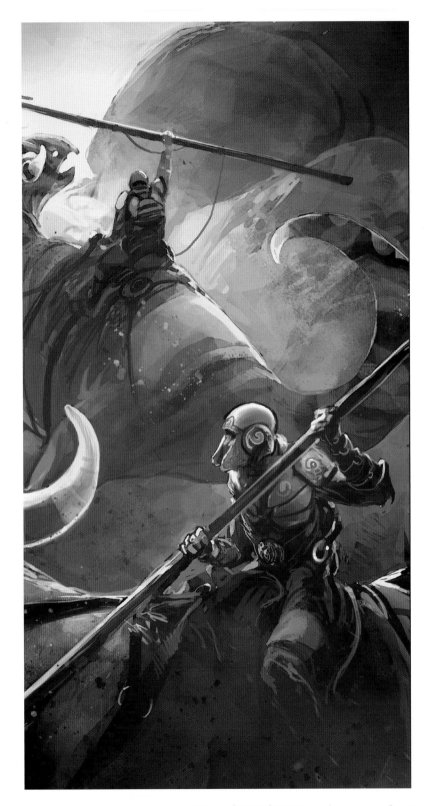

The Dragon Masters - Jack Vance - (extract)
2003 - book cover

NEW WORLD EXPLORATION

1 Skeleton Bot - 2002

2 From Above - 2003

3 Combat Pose - 2003

4 Preserved Species - 2003

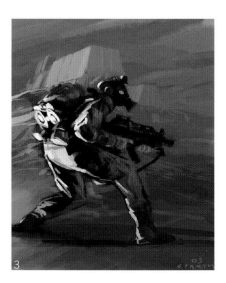

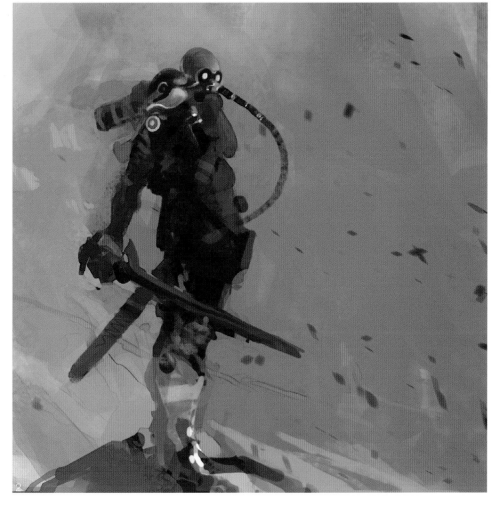

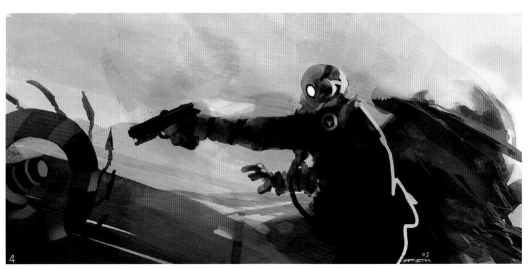

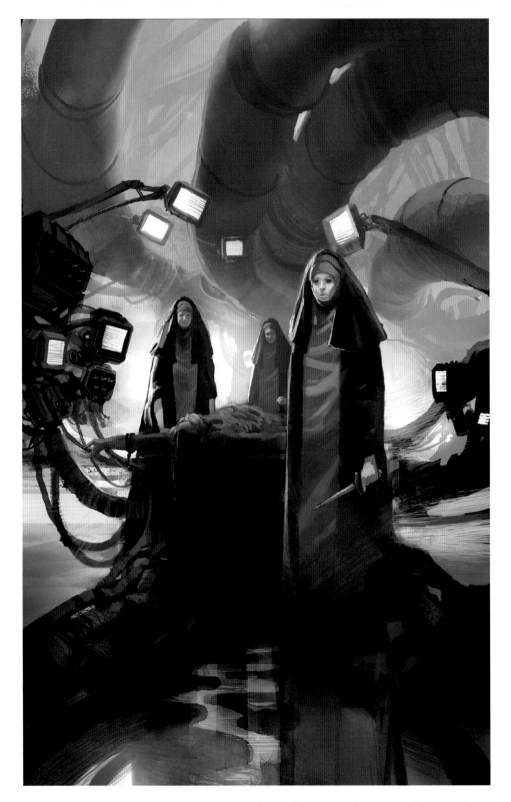

Maximum Ice - Kay Kenyon
2004 - book cover

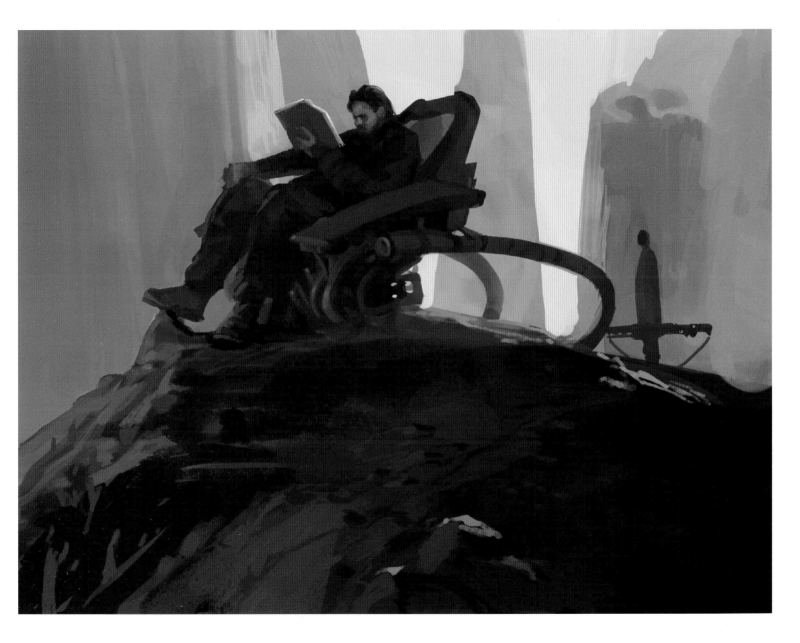

Man Seated - personal work - 2003

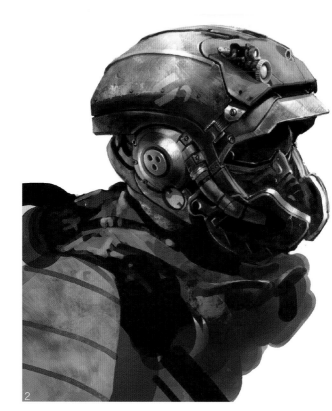

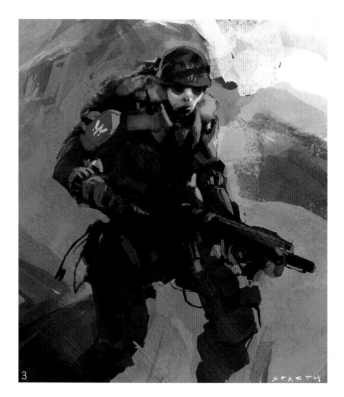

SOLDIER STUDIES

1 The Rush - extract - 2005

2 Helmet - personal study - 2005

3 Vudu Squad - 2003

4 Fast, Easy, Accurate (extract) - 2004

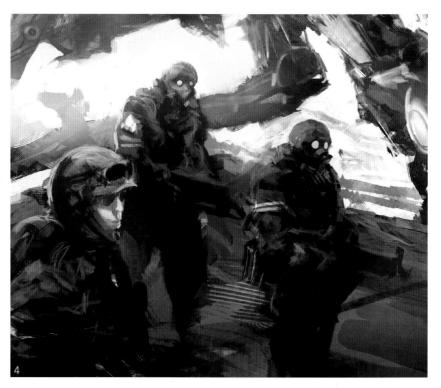

Tripods - 2004

Tapetou - 2004

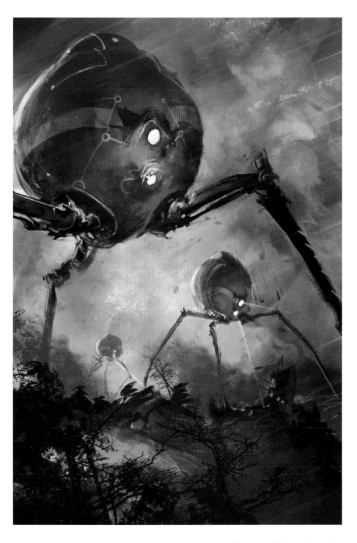

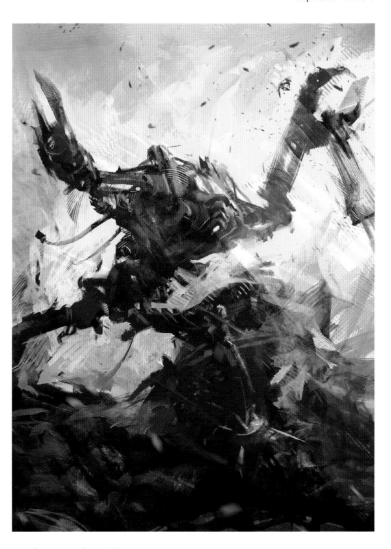

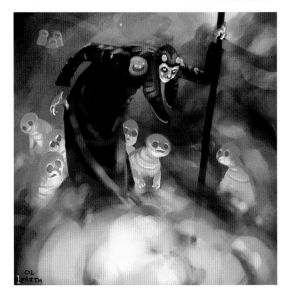

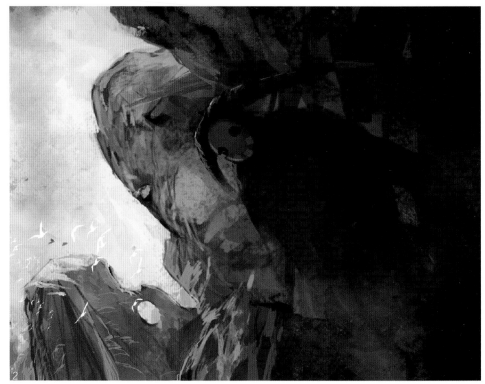

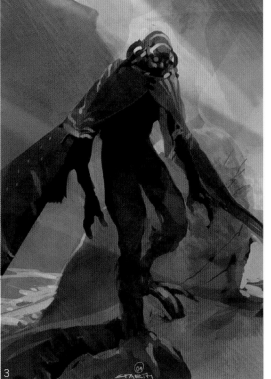

ENIGMATIC PORTRAITS

1 Sorcery Scene - 2002

2 Vampire with Stripes - 2003

3 Walking Entity - 2004

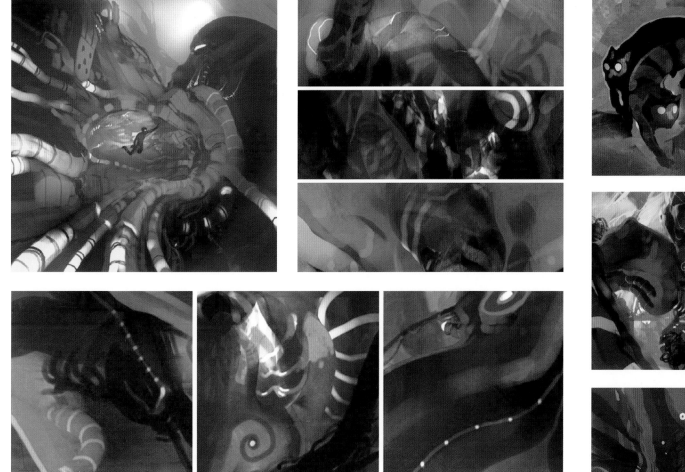

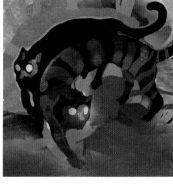

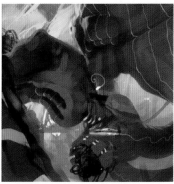

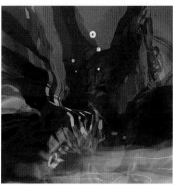

ABSTRACT STUDIES - 2002 - 2003

next page, left: Red Tripod - 2003

next page, right: Click-Drones - 2005

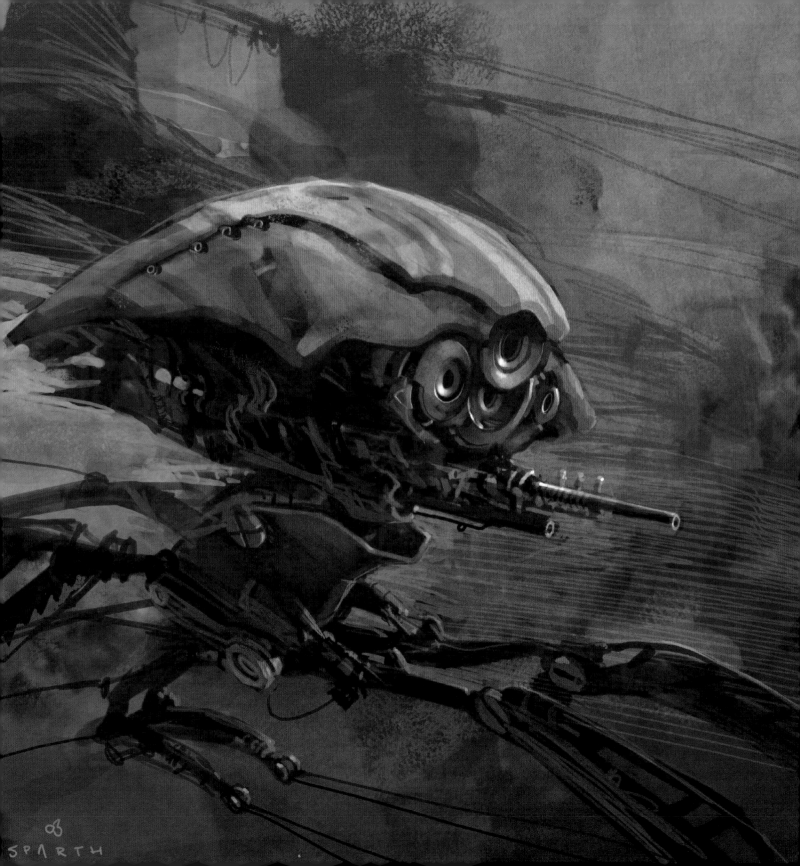

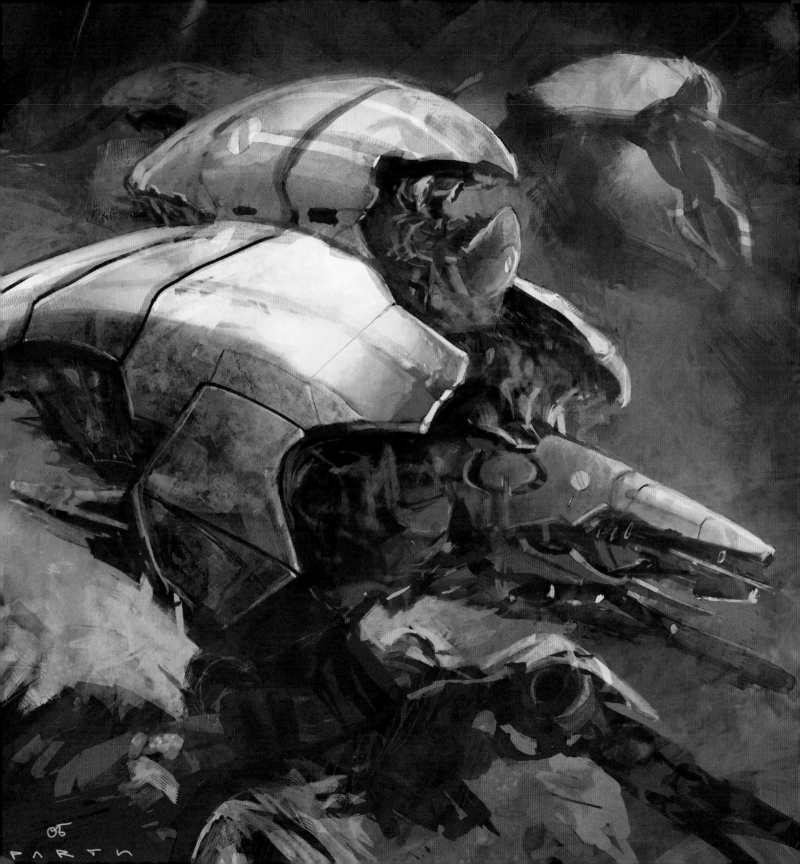

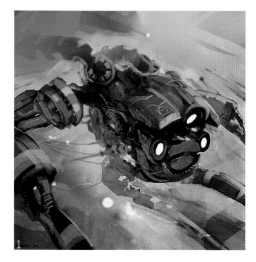

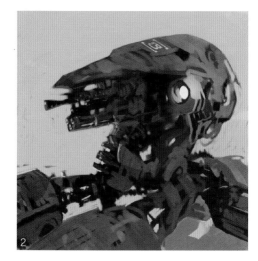

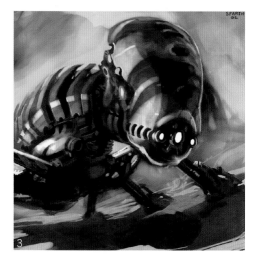

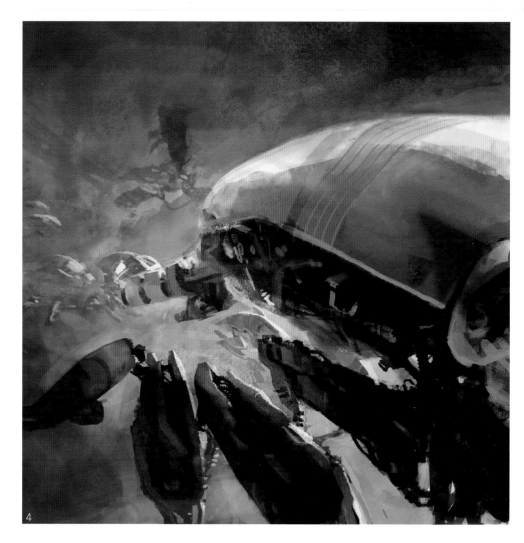

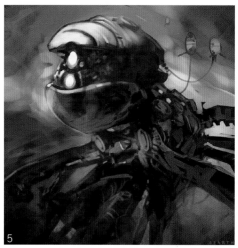

1 Trois Yeux - 2002

2 Skullybot - 2002

3 Duncan-avoid - 2003

4 Structure Mere - 2002

5 Porte Leurre - 2002

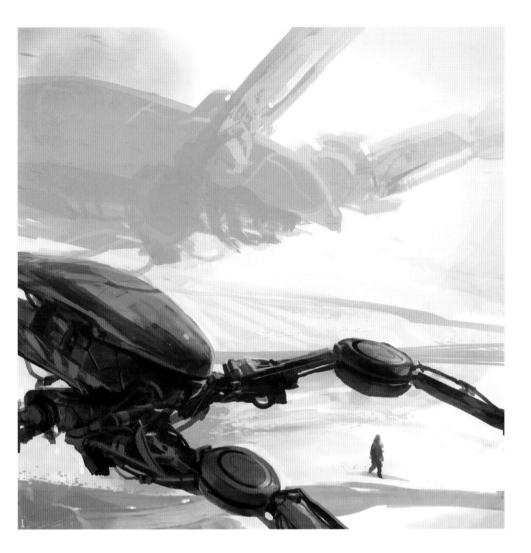

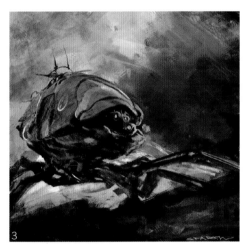

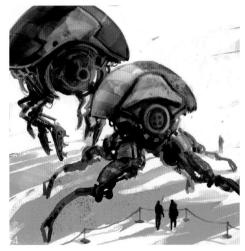

1 Spideybots - 2003

2 Organic Flux - 2003

3 Imperial Runner - 2003

4 Expobots - 2002

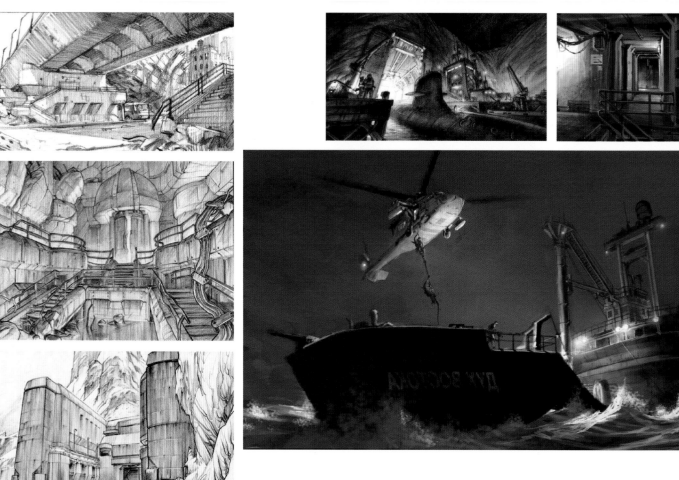

Darkworks Studio concepts. Cold Fear, © 2005 Ubisoft
USS Antarctica, © Darkworks Studio

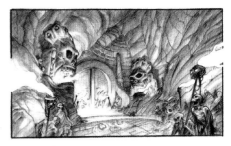

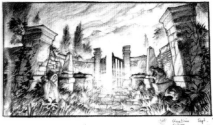

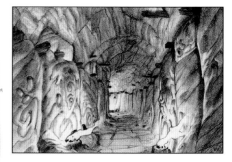

Alone In The Dark 4 - 1999 - 2001

© Darkworks Studio and Infogrames

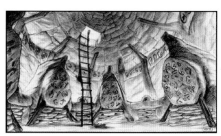

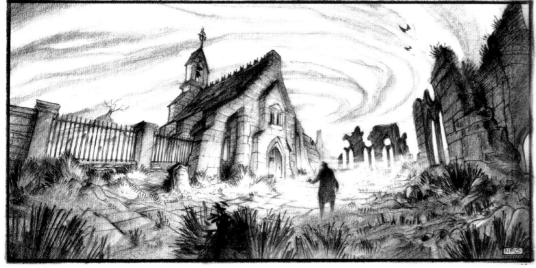

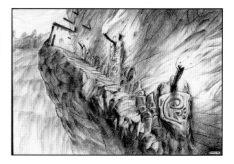

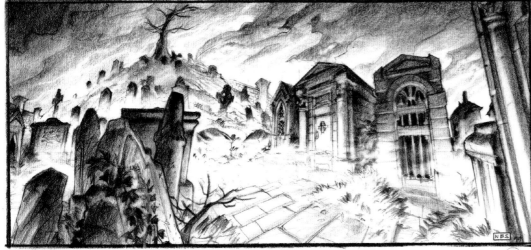

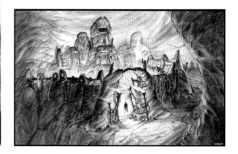

MONTREAL

digital paintings from life - 2005

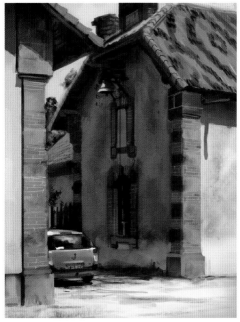

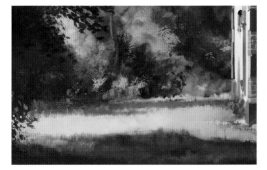

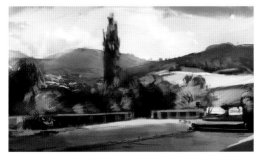

MONTACLIER

digital paintings from life - 2006

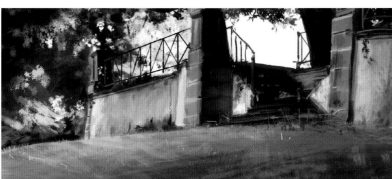

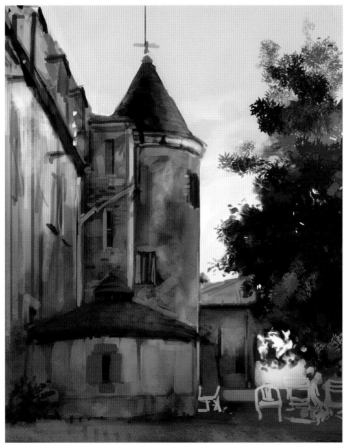

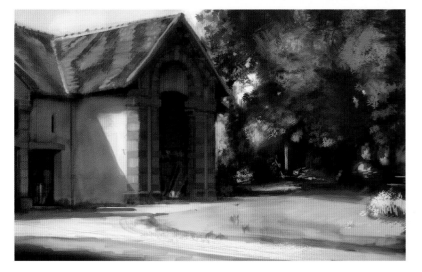

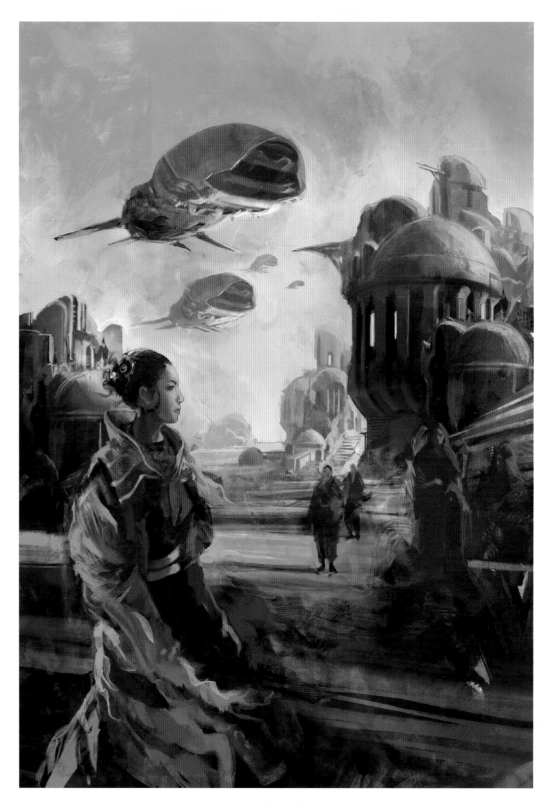

Dune 1 - 2004 - book cover

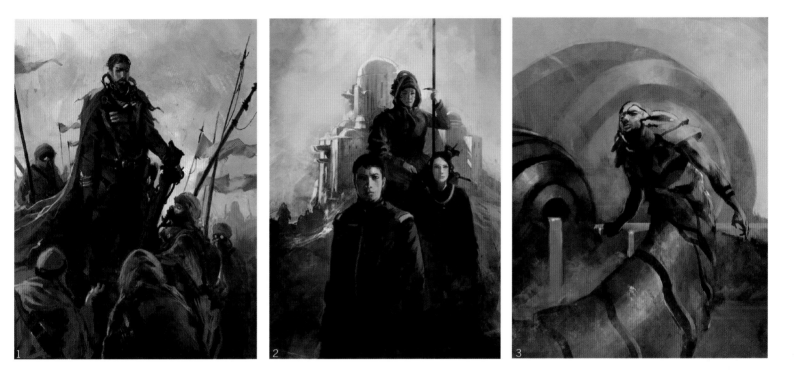

DUNE

1 Les Heretiques de Dune- 2004 - book cover

2 Dune 4 - Enfants de Dune - 2005 - book cover

3 Dune 5 - Empereur Dieu - 2004 - book cover

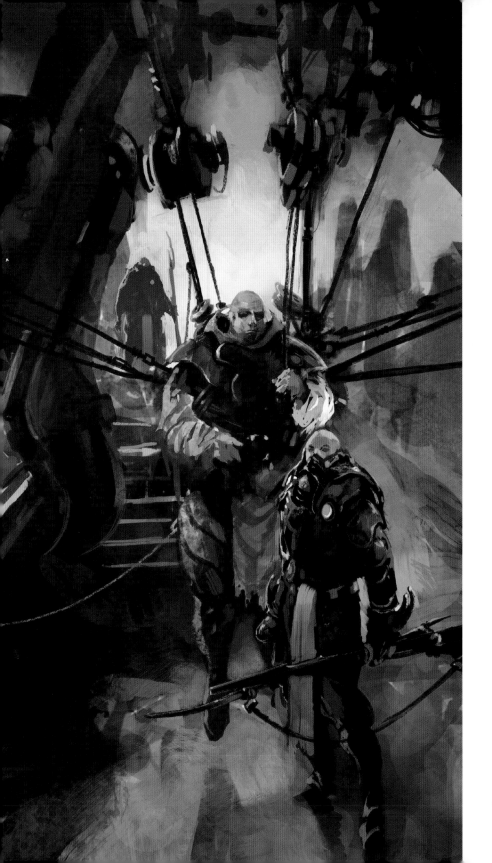

Avant Dune 2 - La Maison Harkonnen 2004 - book cover

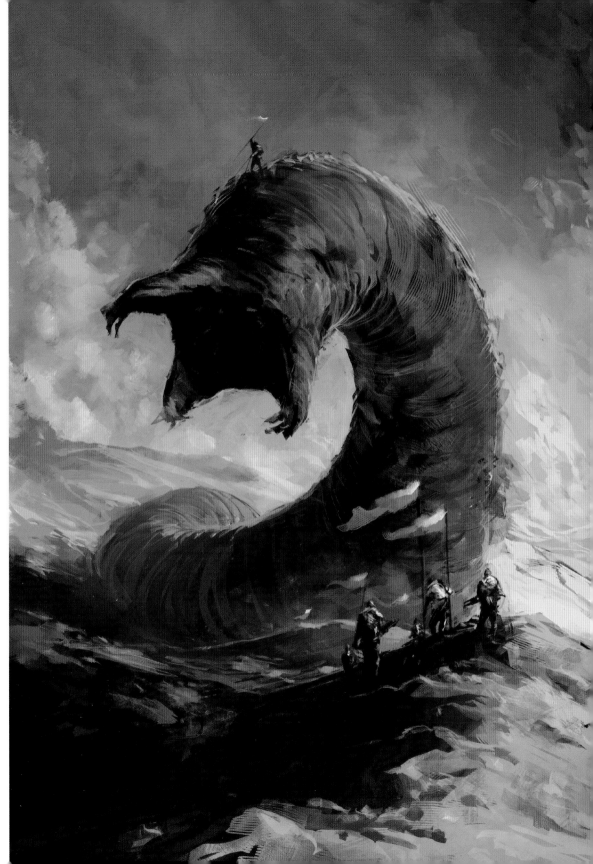

Avant Dune 1 - Maison des Atreides
2004 - book cover

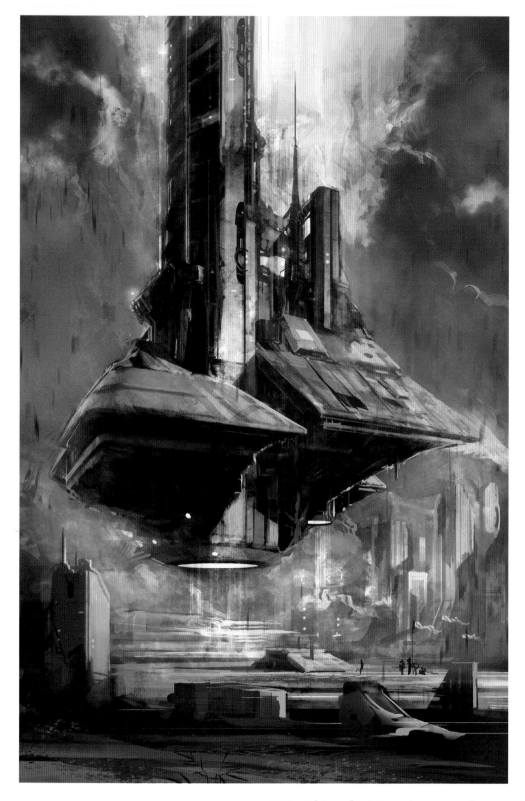

Prelude a Dune - Et l'homme crea un dieu - 2005 - book cover

opposite page: Dune 7 - Maison des Meres - 2005 - book cover

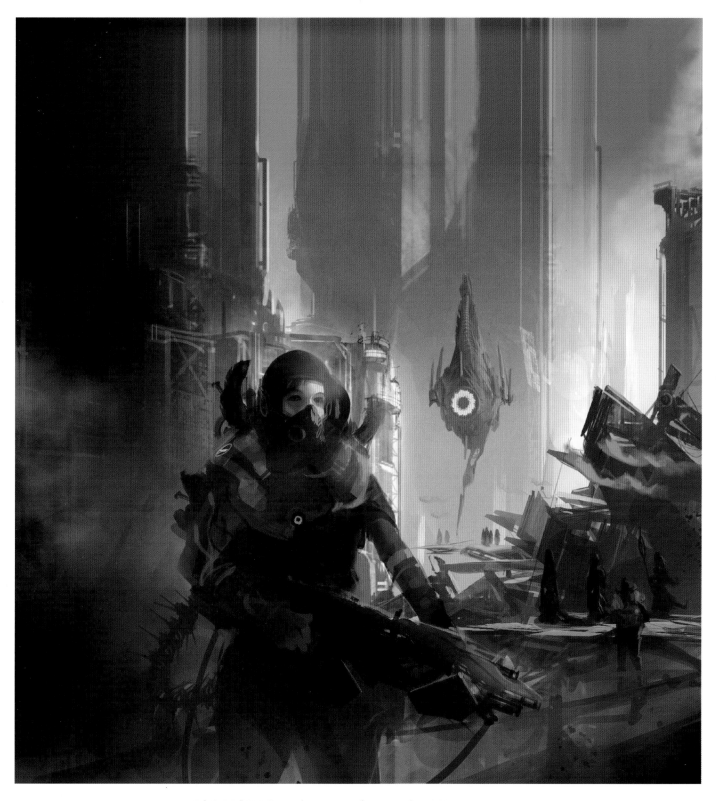

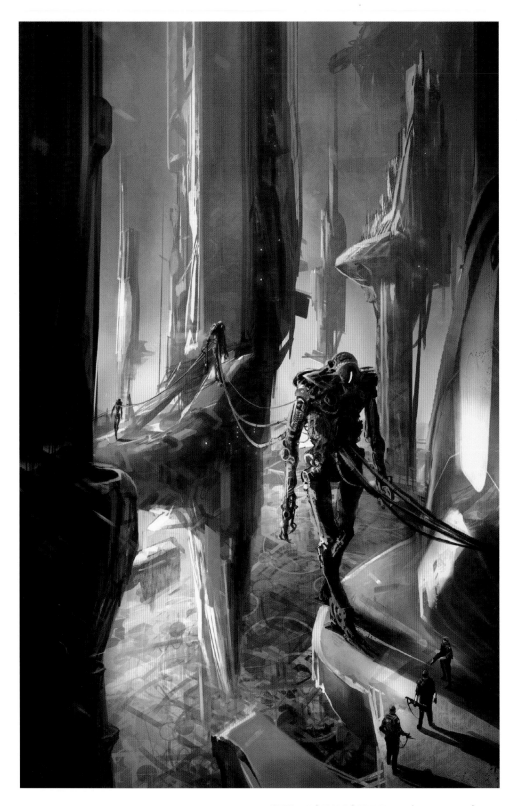

Dune, la Genese - Guerre des Machines
2007 - book cover

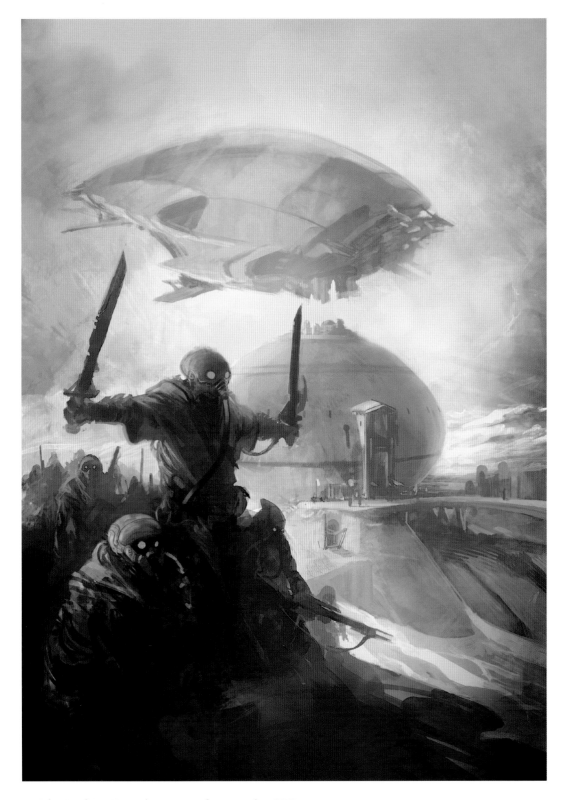

Dune 3 - Le Messie de Dune
2005 - book cover

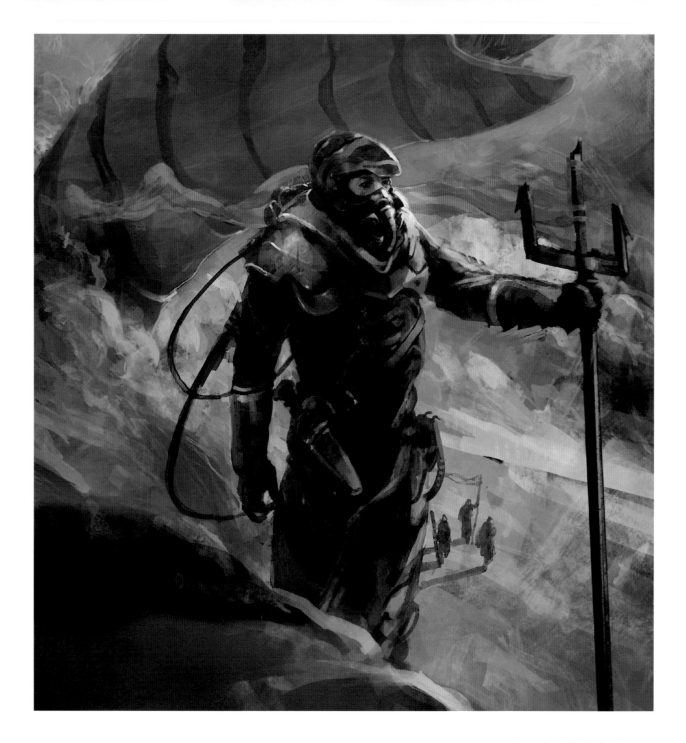

Dune 2 - 2004 - book cover

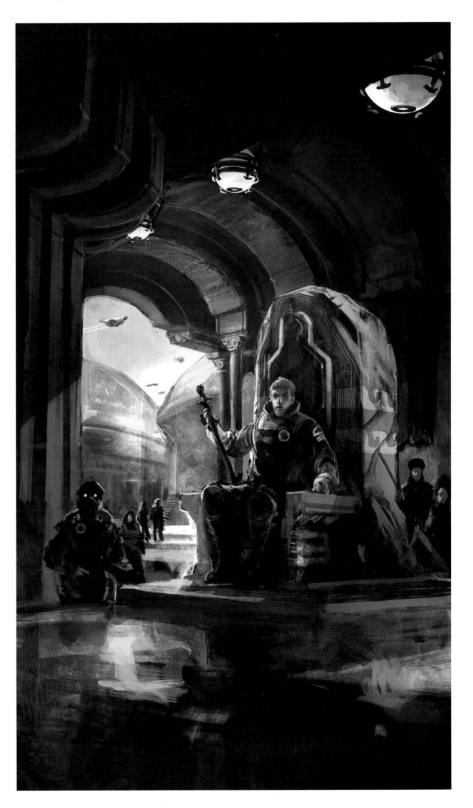

Avant Dune 3 - Maison Corrino - 2005 - book cover

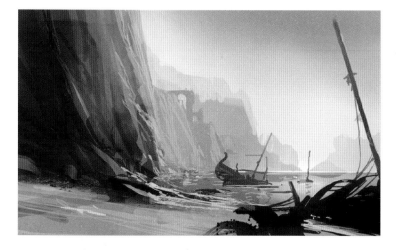

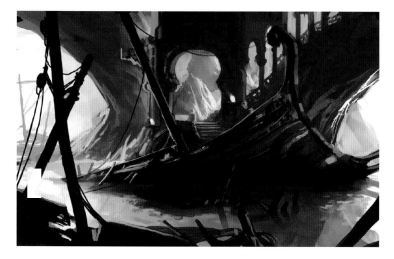

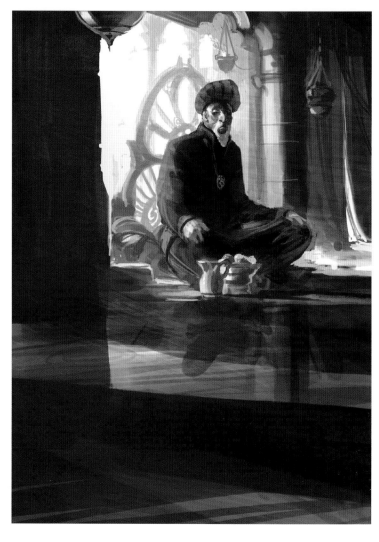

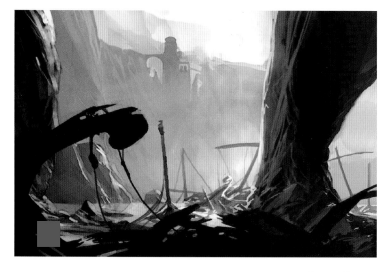

Prince of Persia: Warrior Within - Ubisoft - 2003

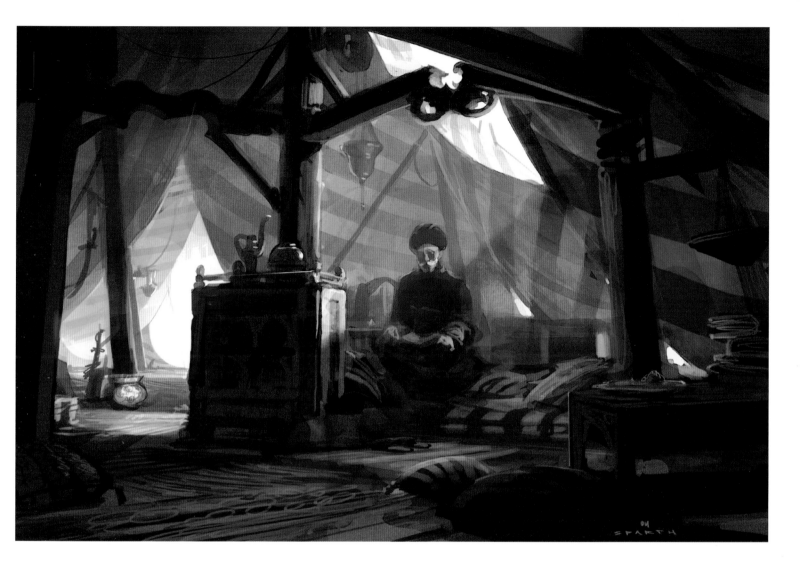

Prince of Persia: Warrior Within - Hidden in the desert - 2004

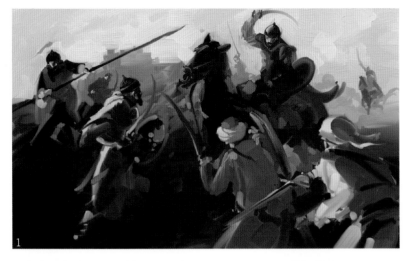

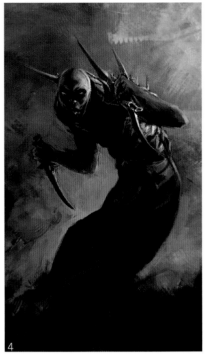

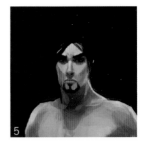

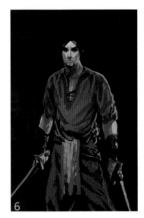

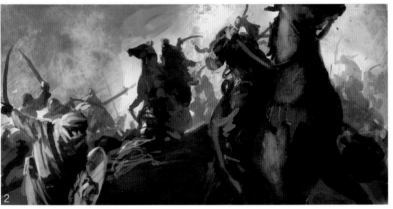

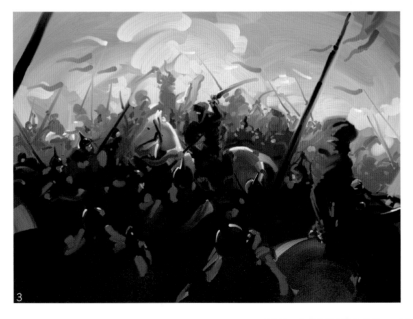

1 Battle scene in the Desert - visual development within the
 Prince of Persia universe - Ubisoft - 2005

2 Battle scene in the Desert - visual development within the
 Prince of Persia universe - Ubisoft - 2005

3 Battle scene with red warriors - visual development within the
 Prince of Persia universe - Ubisoft - 2005

4 Prince of Persia - silhouette - Ubisoft - 2004

5 Prince of Persia - Prince study - Ubisoft - 2004

6 Prince of Persia - Prince study - Ubisoft - 2004

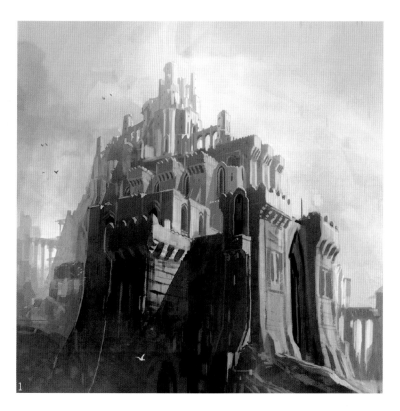

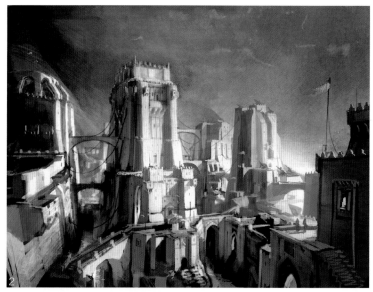

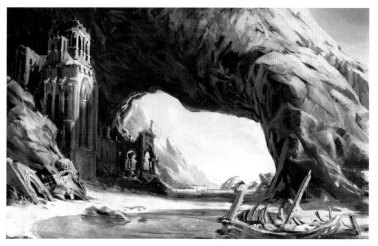

1 Prince of Persia - Chronos concept - Ubisoft - 2004

2 Prince of Persia - Warrior Within - Chronos Tower - Ubisoft - 2004

3 Prince of Persia - Warrior Within - Boat Cemetary - Ubisoft - 2004

4 Prince of Persia - Warrior Within - Prince study - Ubisoft - 2004

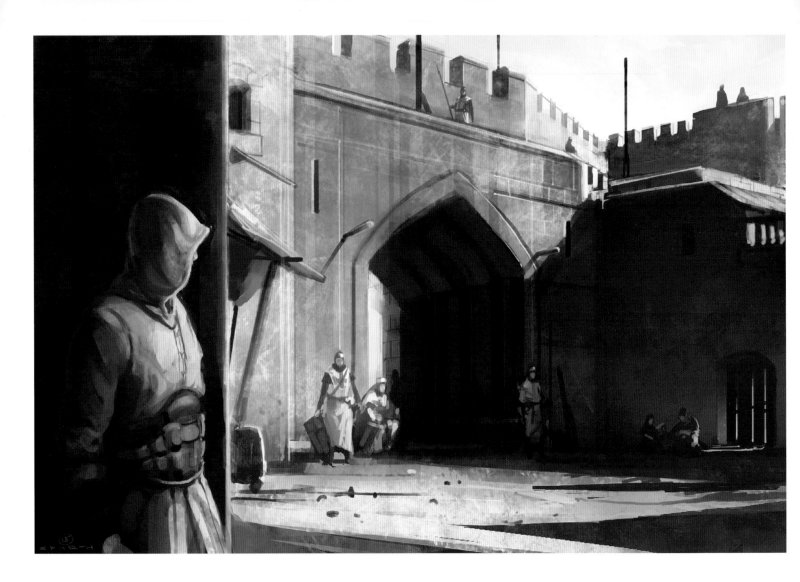

Assassin's Creed - assassin in front of fortress - Ubisoft - 2005

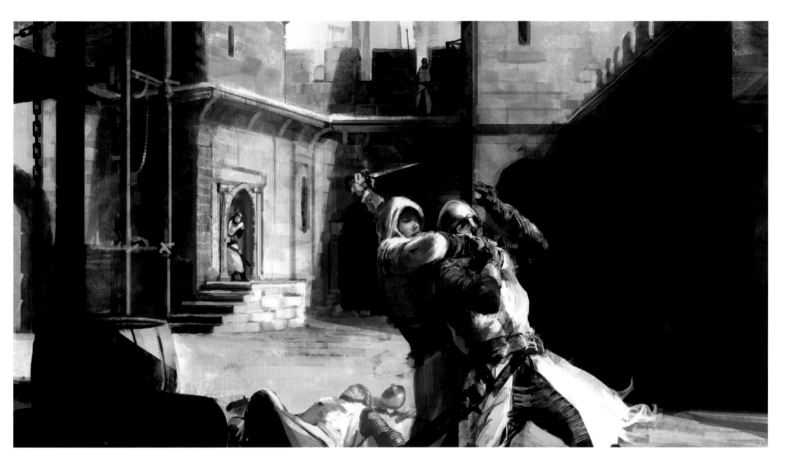

Assassin's Creed - Ubisoft - 2005

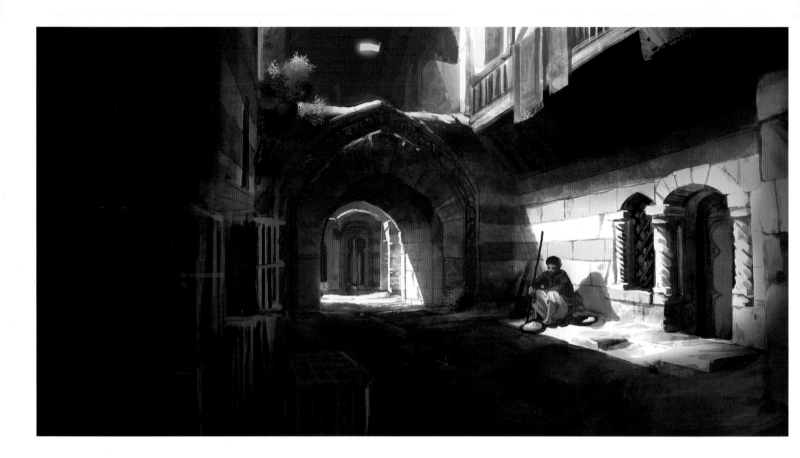

Assassin's Creed - Damas street - Ubisoft - 2005

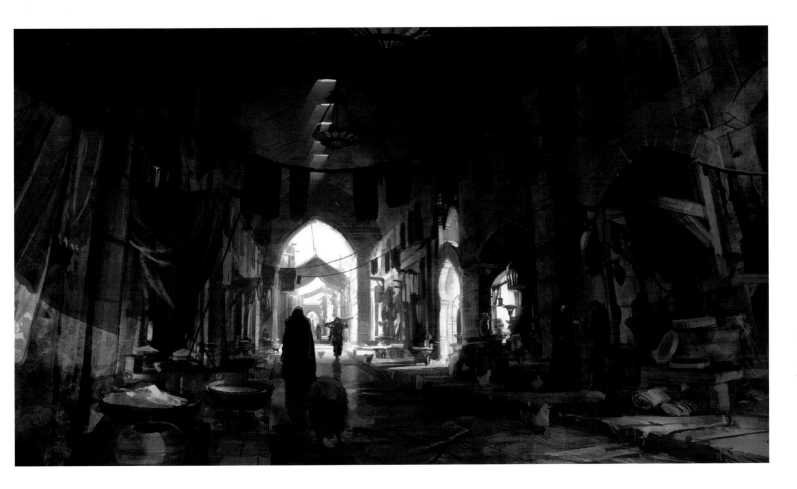

Assassin's Creed - Damas market - ubisoft 2005

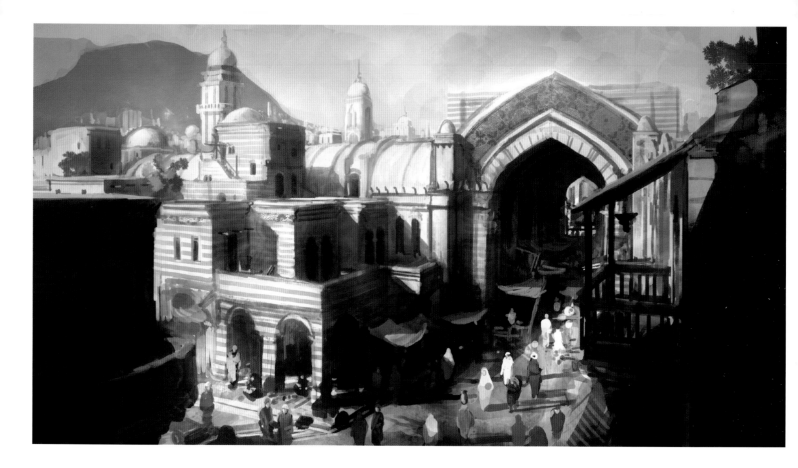

Assassin's Creed - Marketplace - Ubisoft - 2005

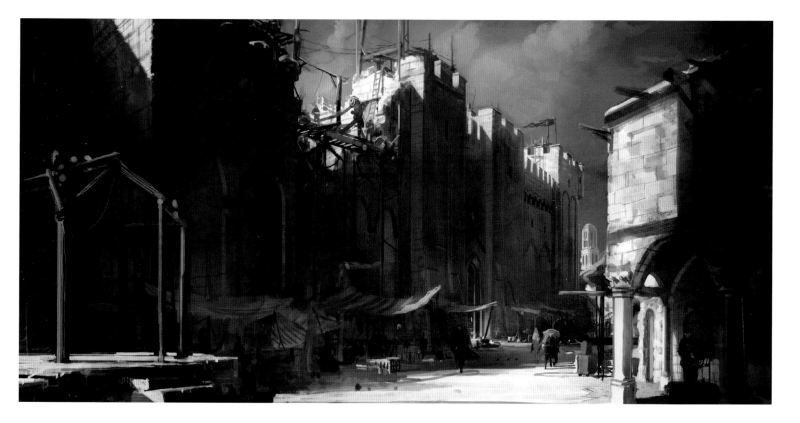

Assassin's Creed - Gallows - Ubisoft - 2005

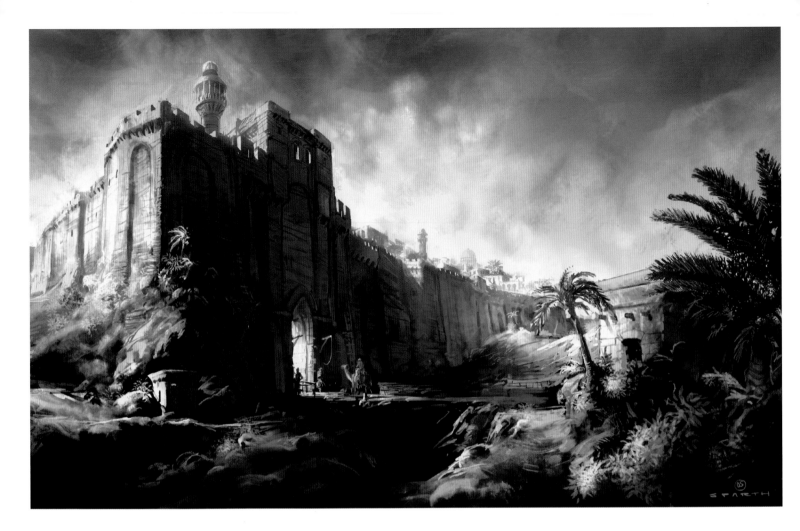

Assassin's Creed - Jerusalem - Ubisoft - 2005

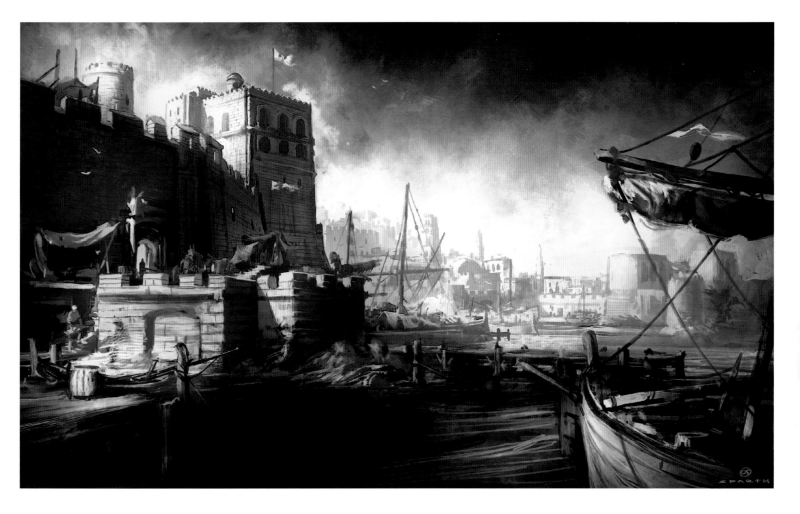

Assassin's Creed - The Port of Acres - Ubisoft - 2005

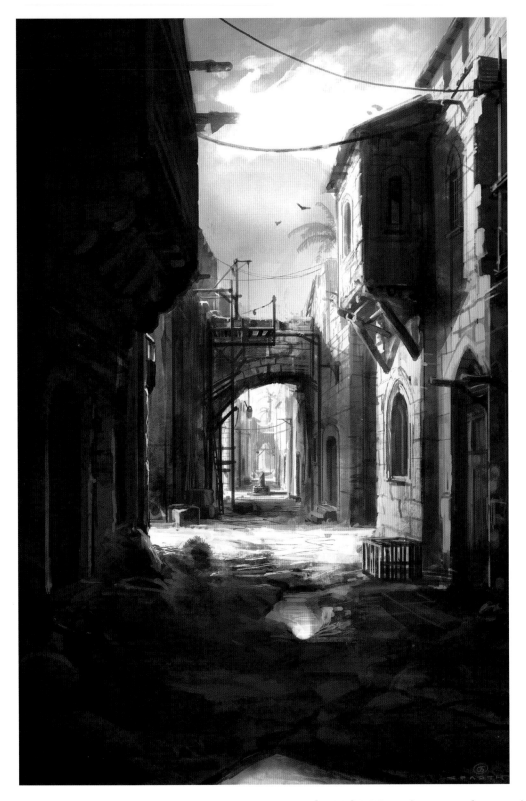

Assassin's Creed - A View of Acres
Ubisoft - 2005

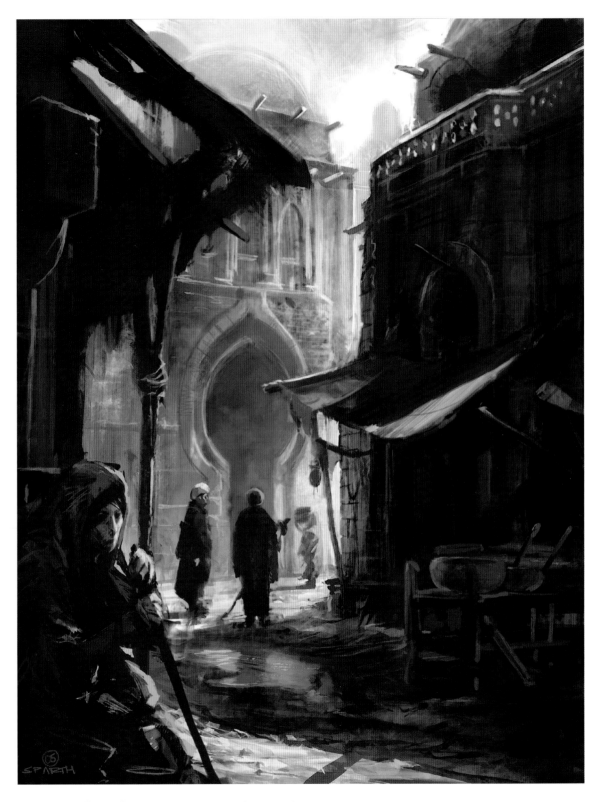

Assassin's Creed - Damas Street
Ubisoft - 2005

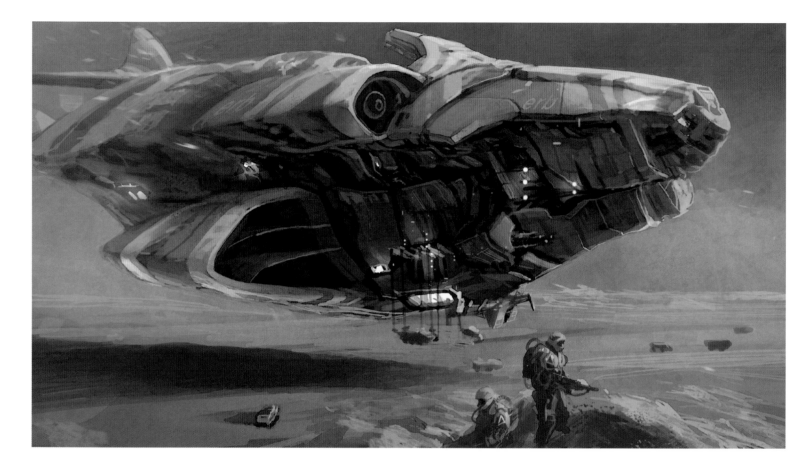

Lockdown - 2003

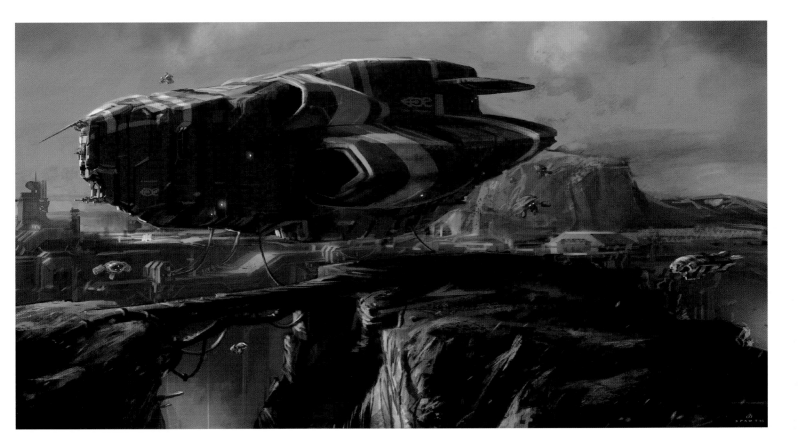

Come with us - 2003

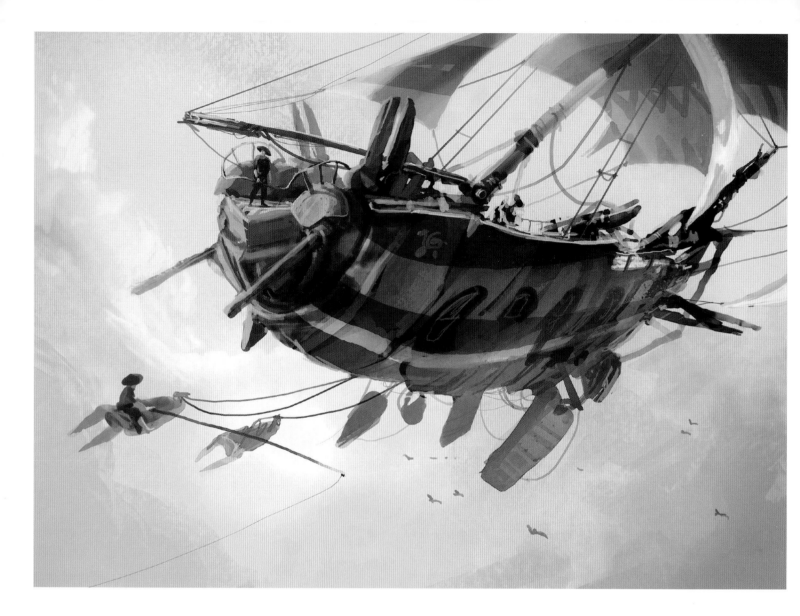

Volans - 2003

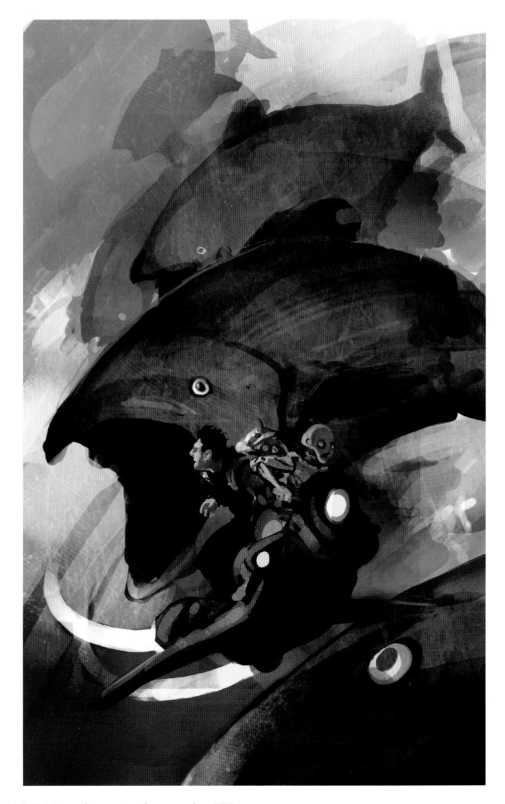

Don't Panic! - Neil Gaiman - 2004 - book cover

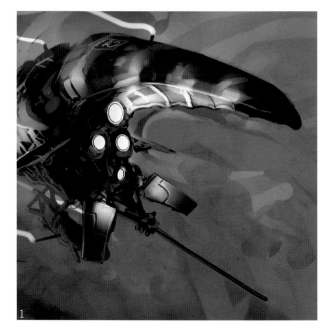

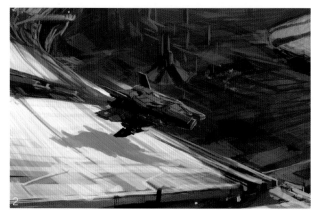

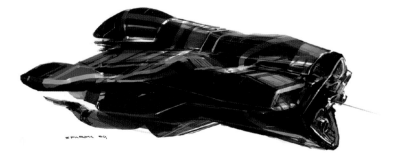

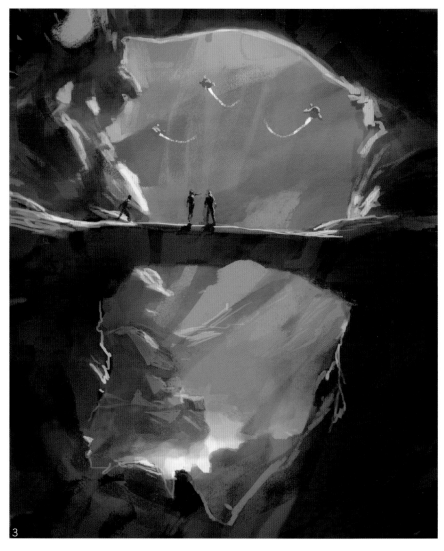

1 Waterbot - 2003

2 Donald Kingsbury - Psychohistoric Crisis - (extract) - 2004

3 Signs - 2003

4 Fquam - spaceship sketch - 2004

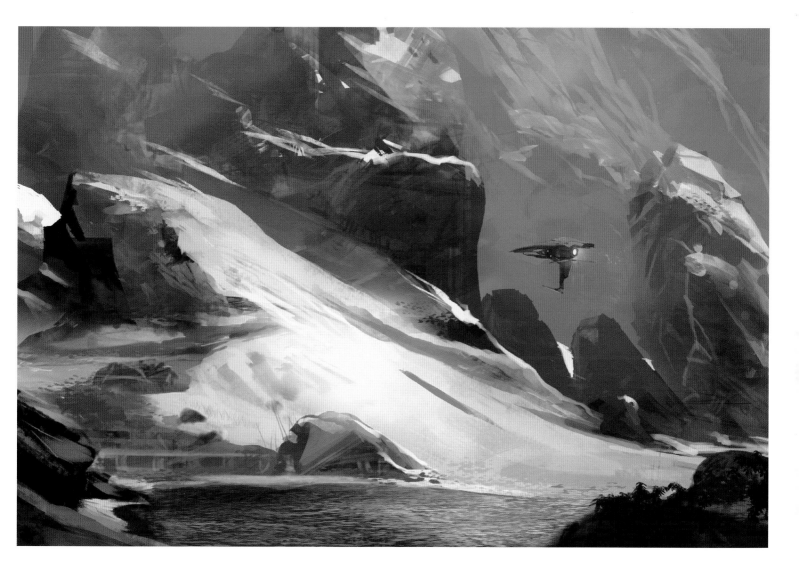

Inner Sanctuary - 2005

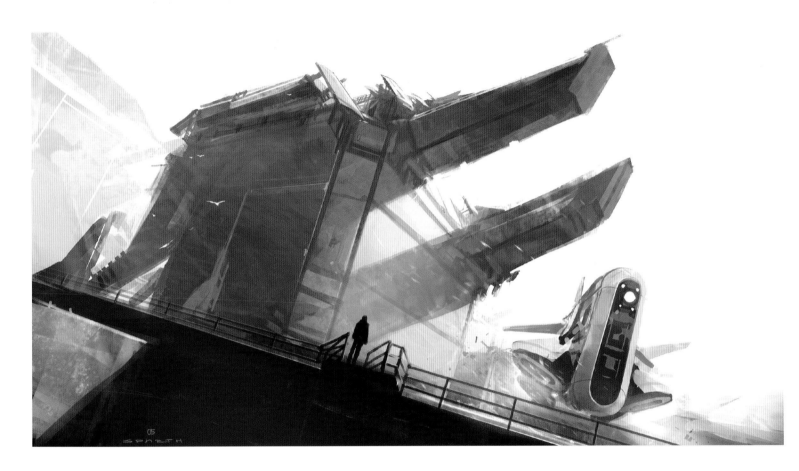

Sleepy Town - 2004

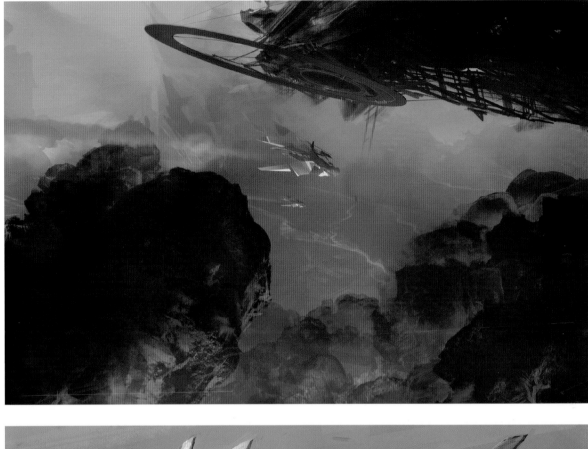

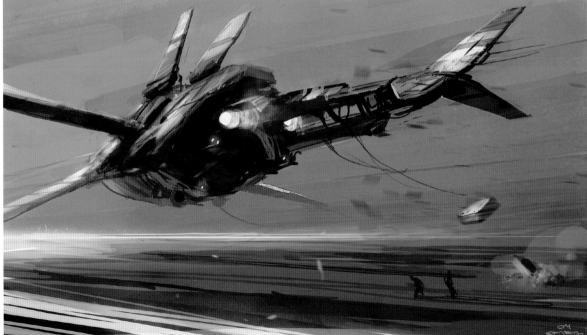

Vyle Lava - 2005

Humanitary Flight - 2004

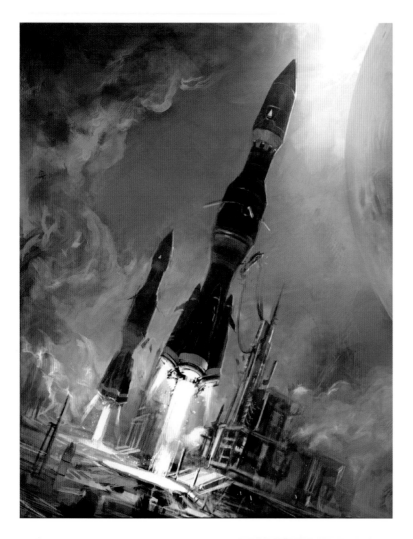

L'homme qui vendit la Lune - Robert A Heinlein
2004 - book cover

Four covers in one for a Robert A Heinlein book pack.
2004 - book cover

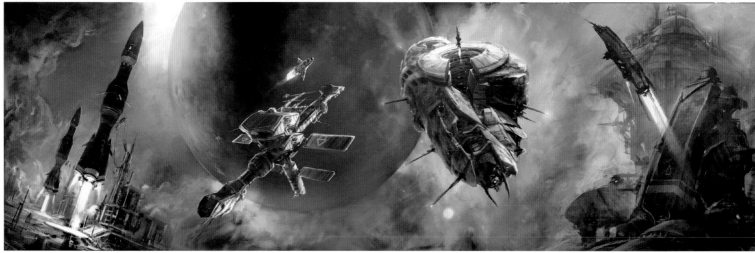

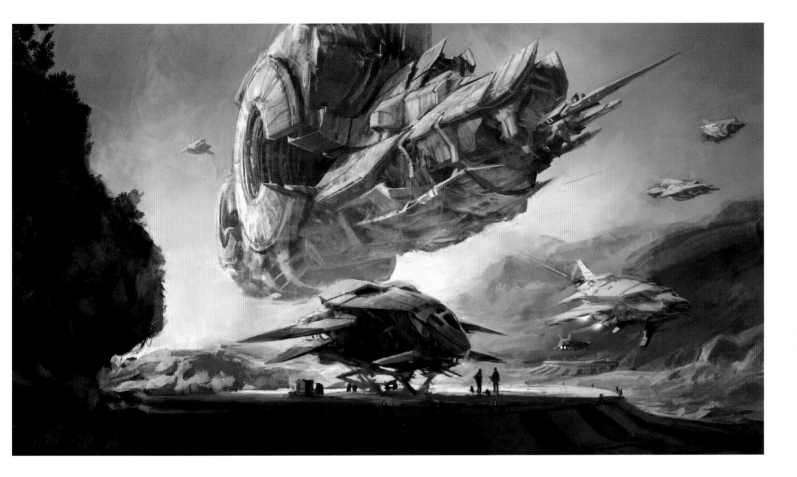

The Drag - 2004

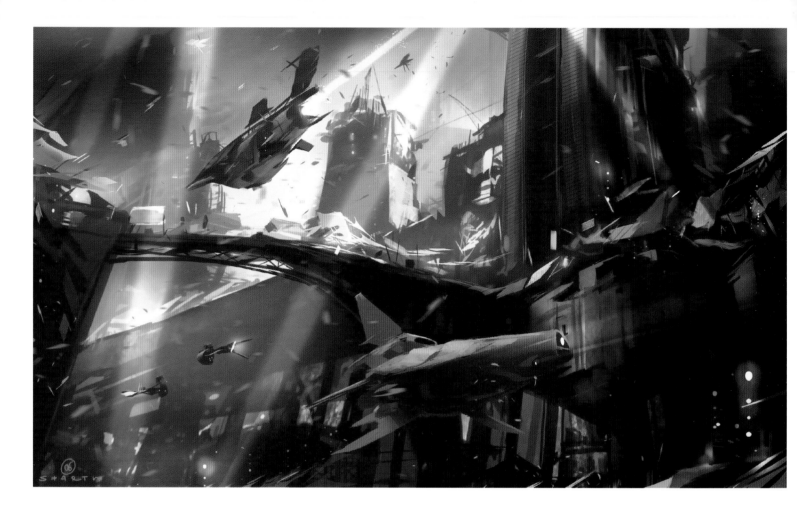

Feast - 2006

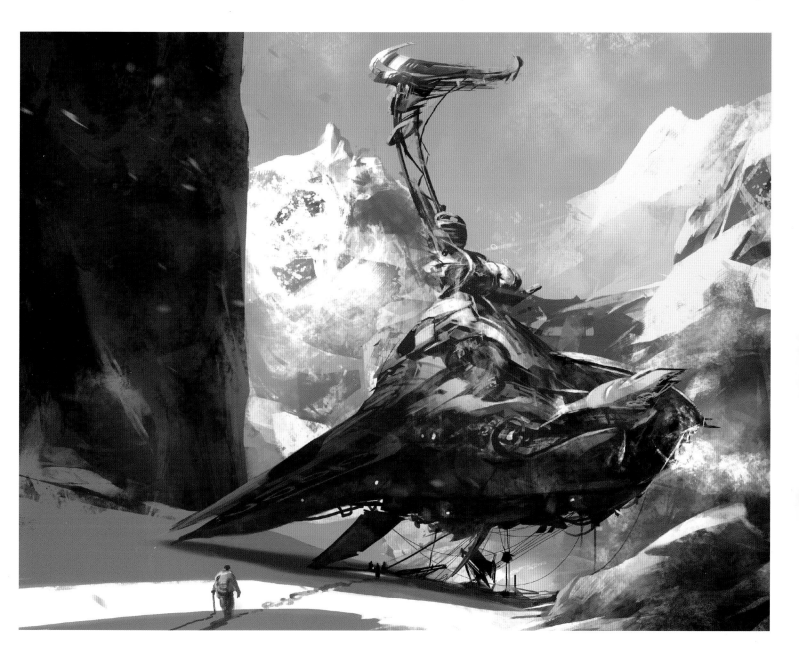

Peak Repair - 2006

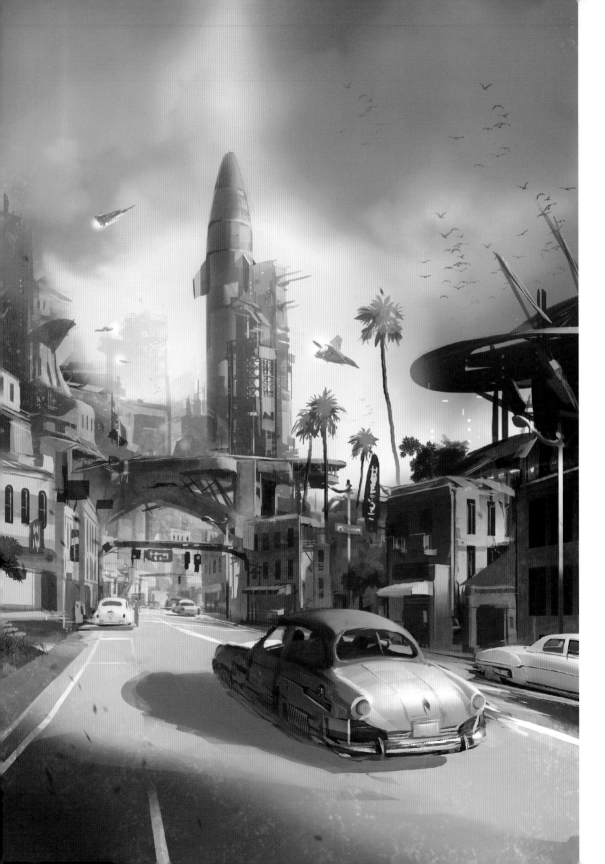

Martian Time-Slip
2006 - book cover

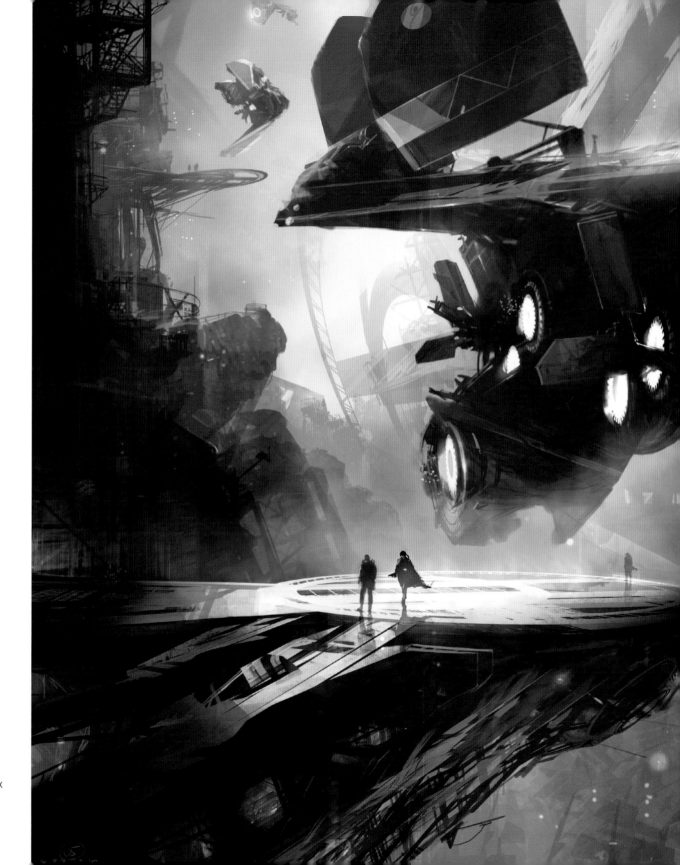

Ellipsoid Complex
2005

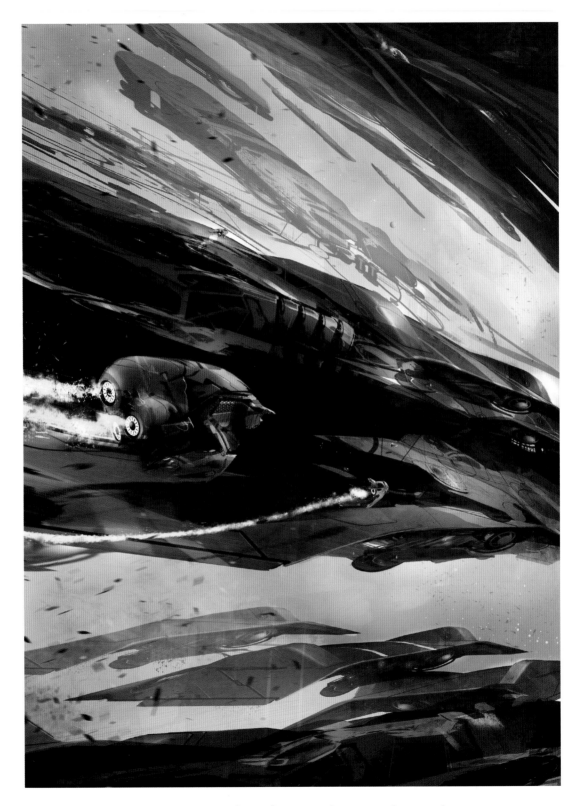

Vitamon - 2005

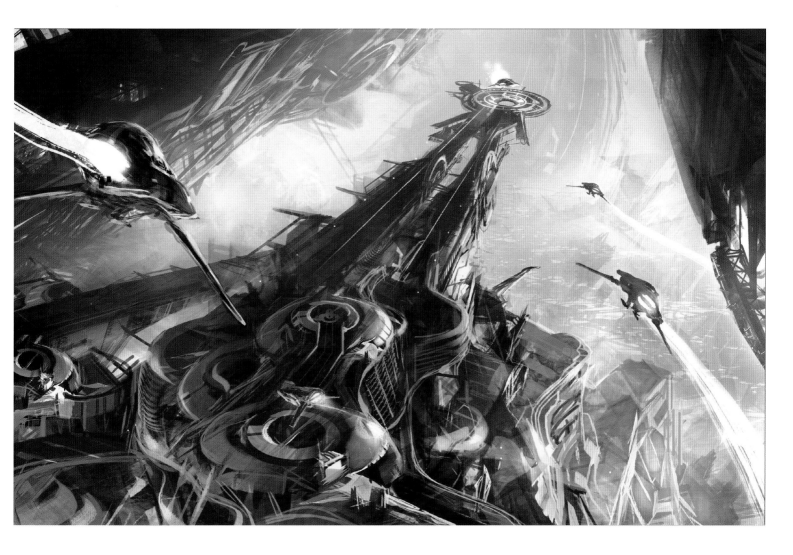

Third Mummy - 2005

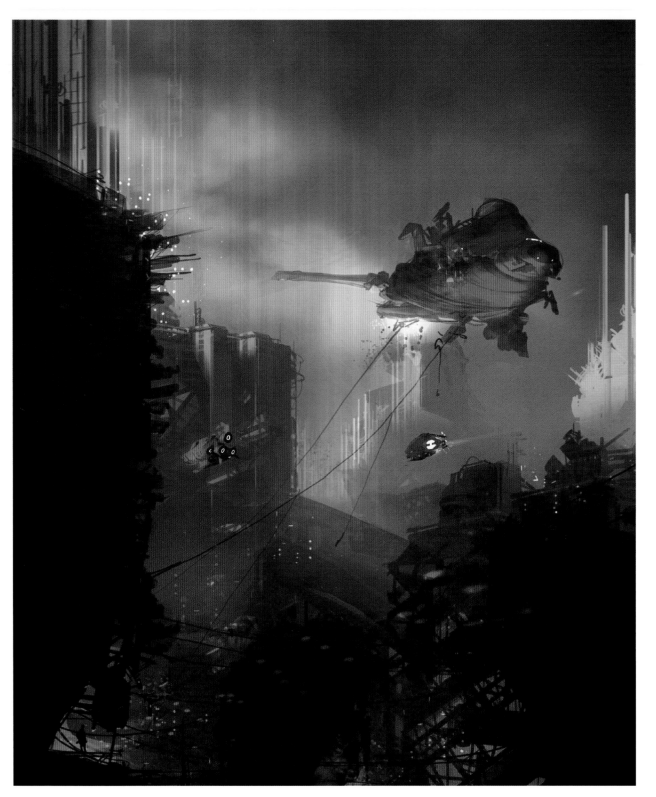

Second Drag
2005

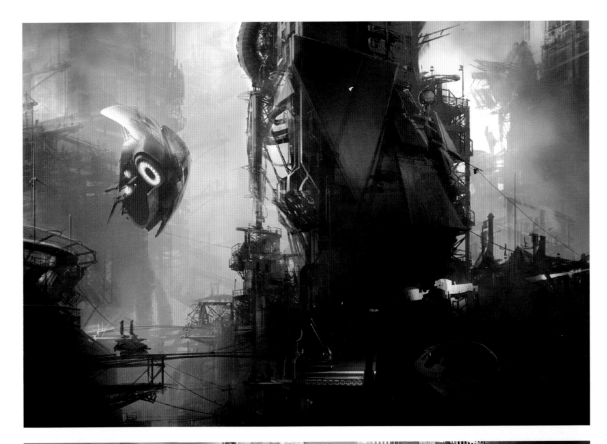

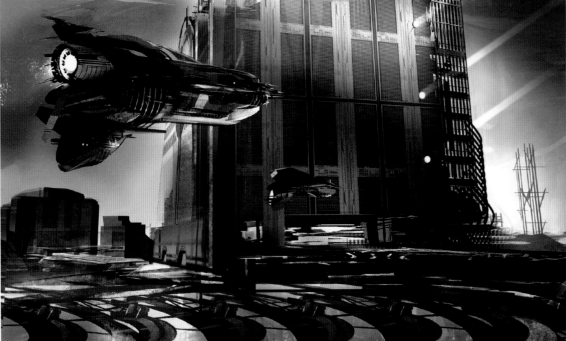

Green Giant - 2005

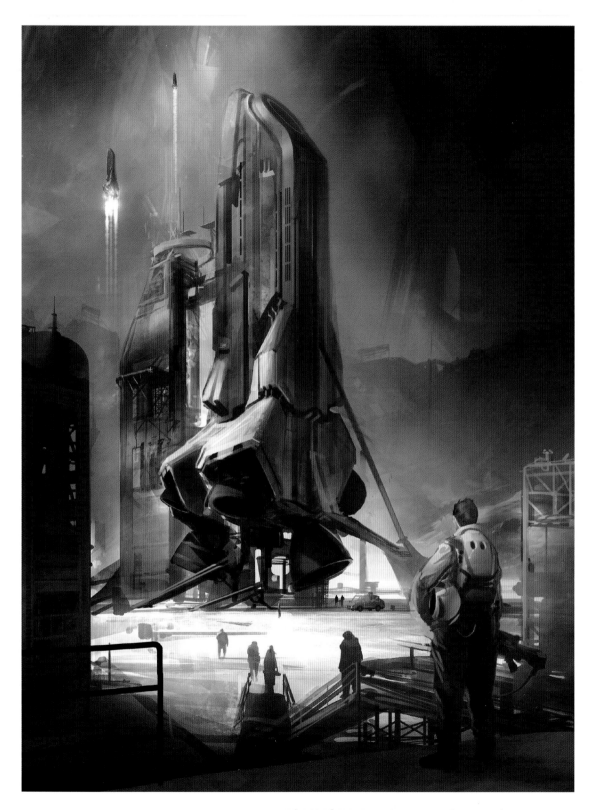

Short Stories - Philip K. Dick
2006 - book cover

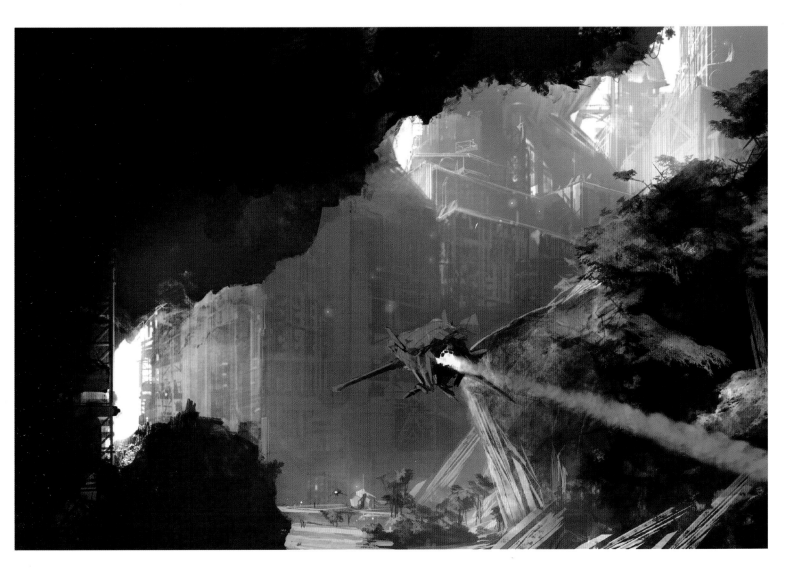

End of Grotto - 2005

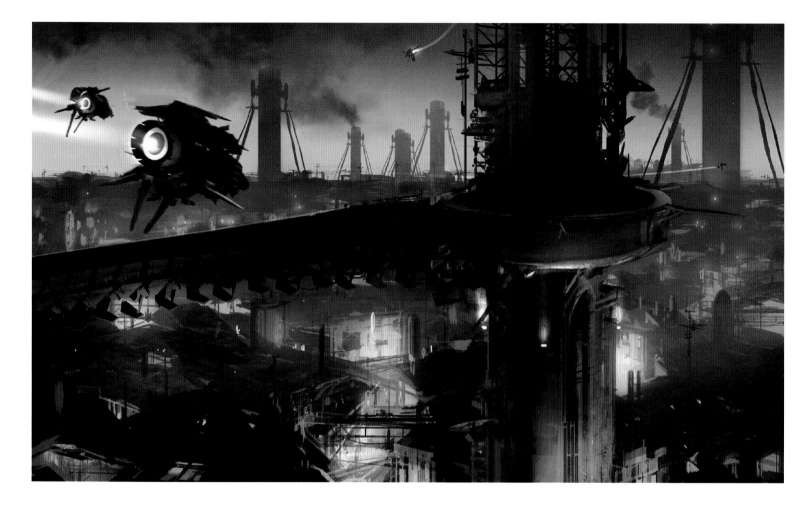

Steam city - 2007

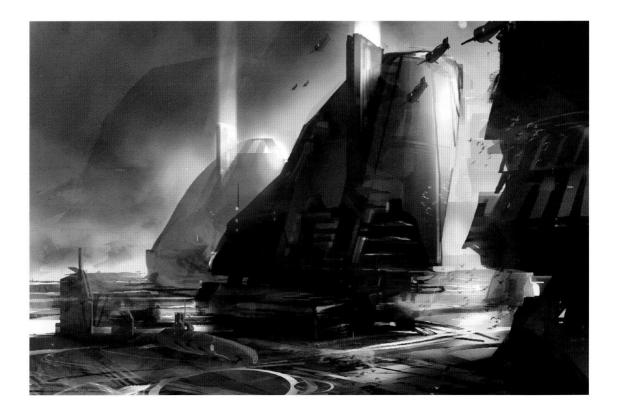

Subcity - 2005

Terra Incognita - 2003

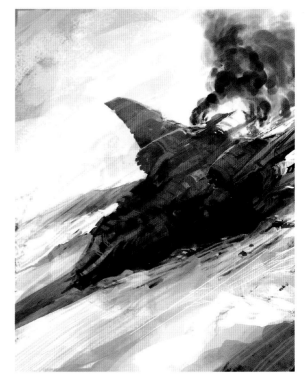

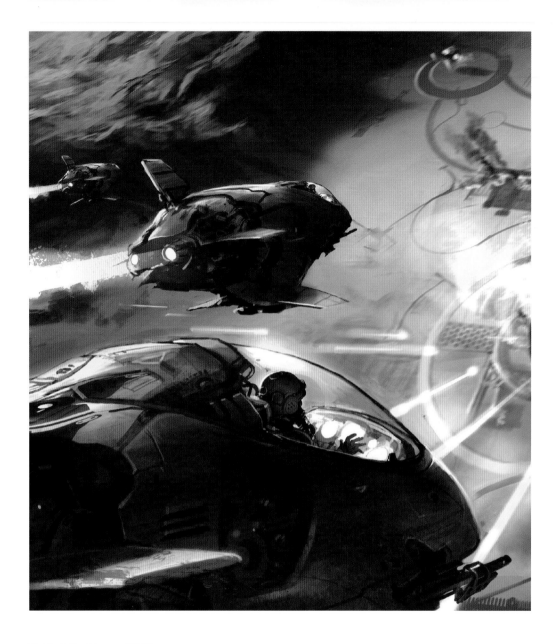

Behind the Lines - 2007

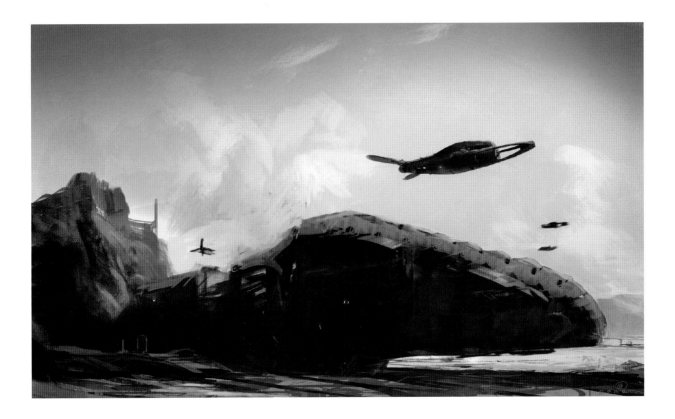

Suspended Structure - 2007

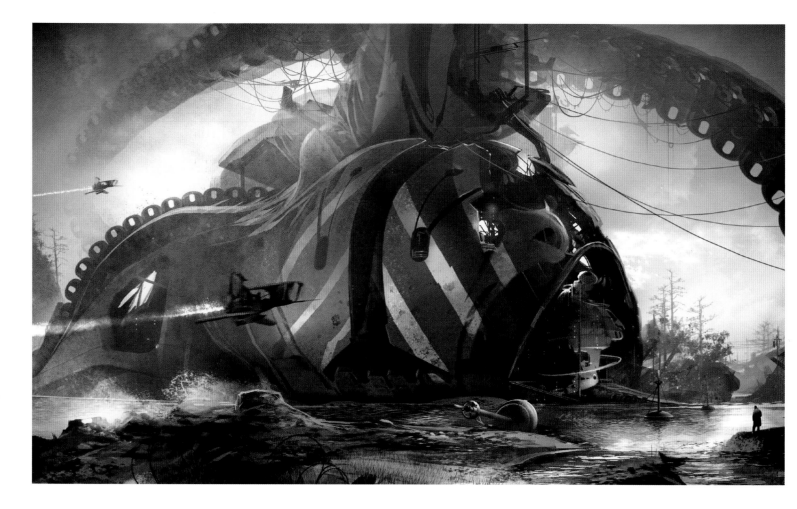

Cater - 2006

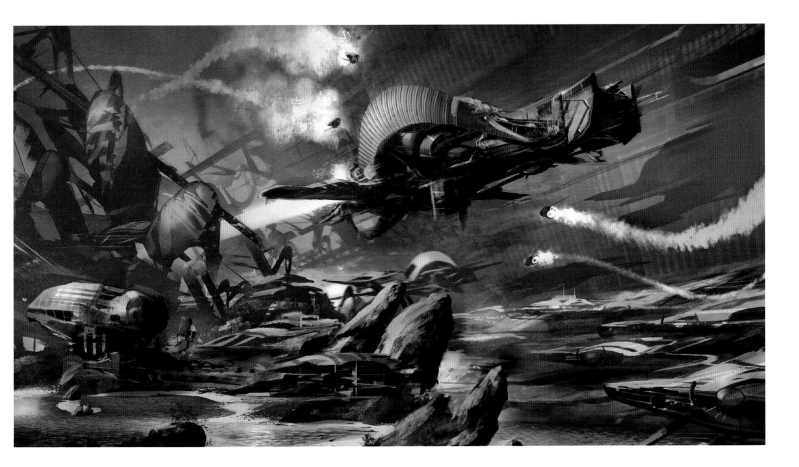

A Way Out - 2006

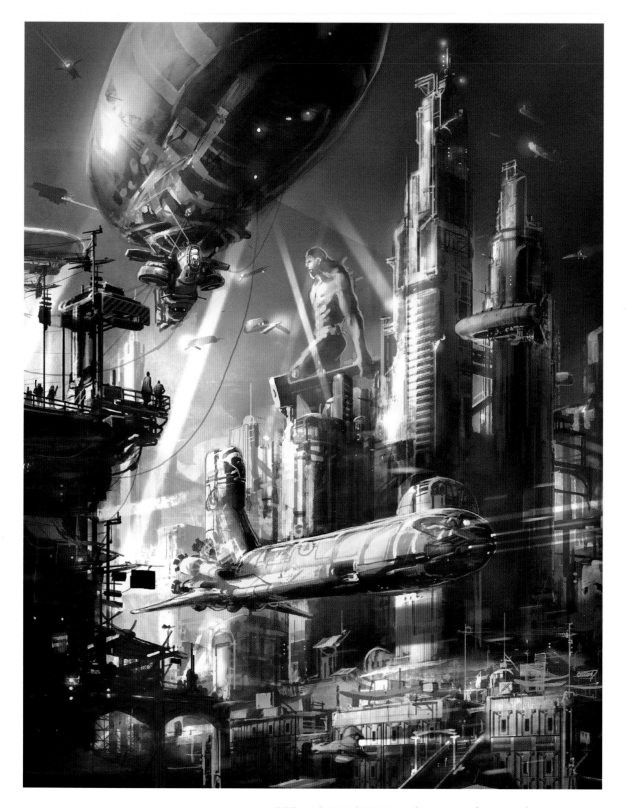

Cenotaxis - Sean Williams
2007 - book cover

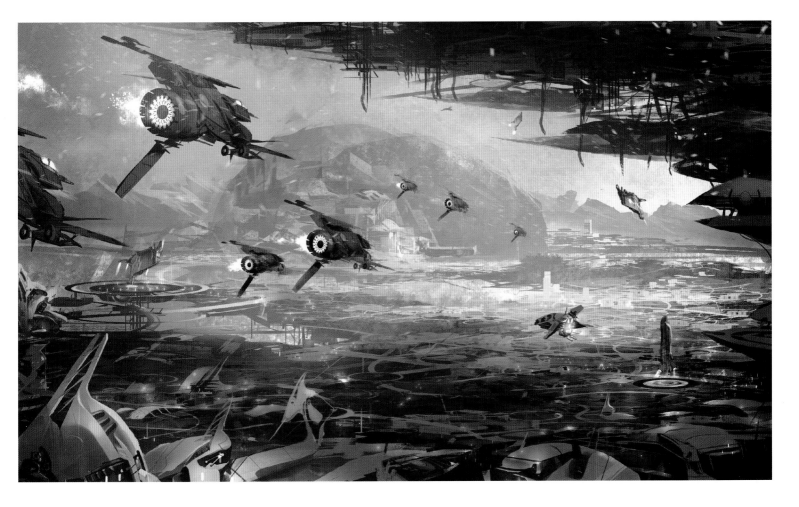

Odes and the Thieves - 2006

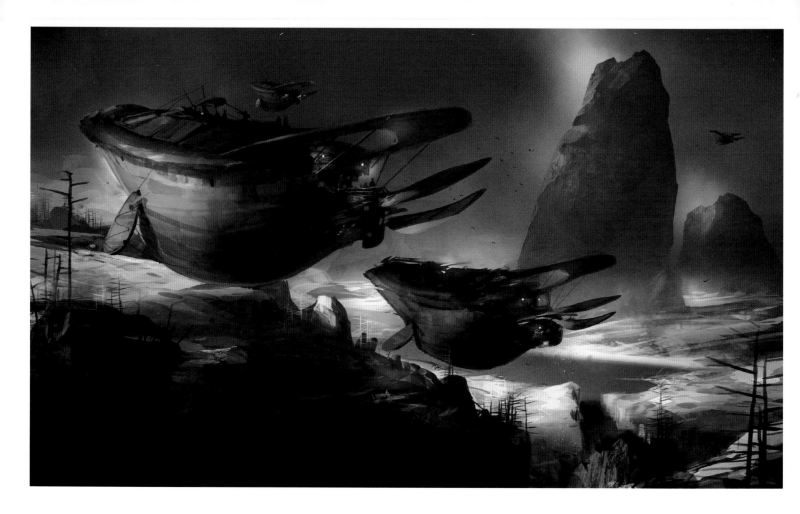

Arches - 2007

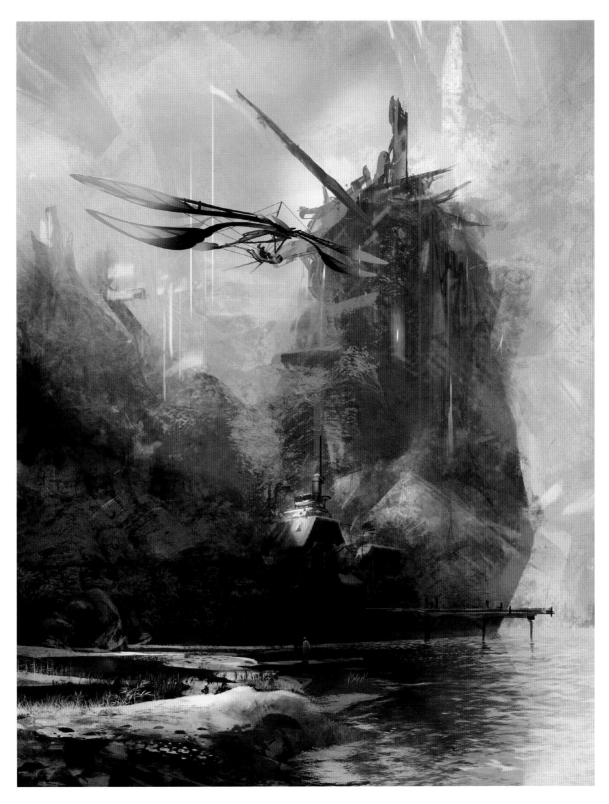

Red Echo - 2007

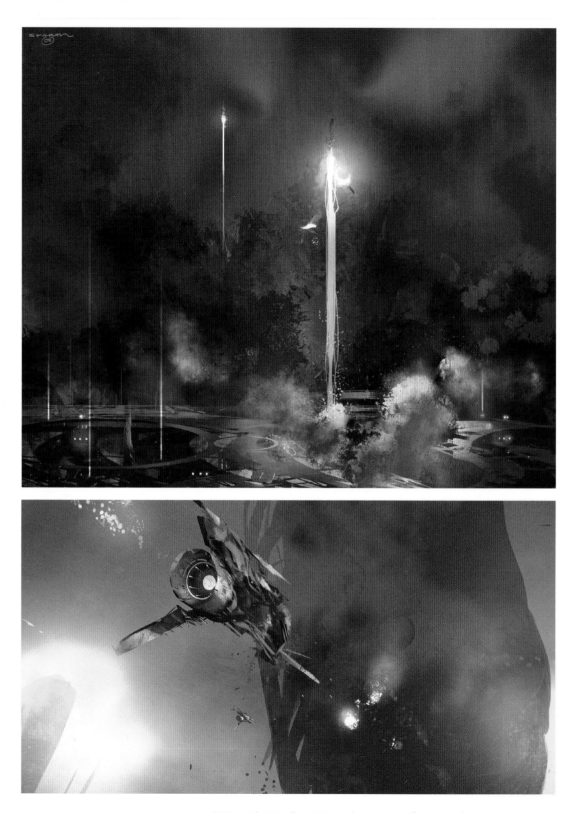

Blue Divide - 2006

ONA Battlefield - 2006

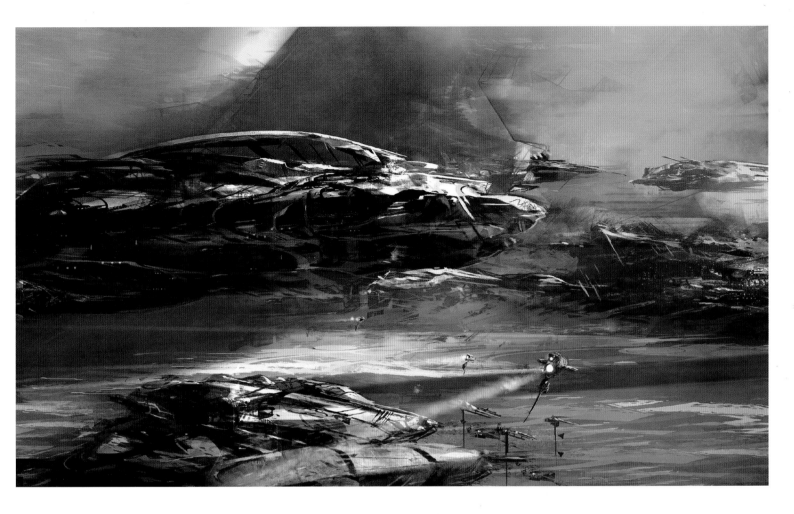

Show Them Hell - 2007

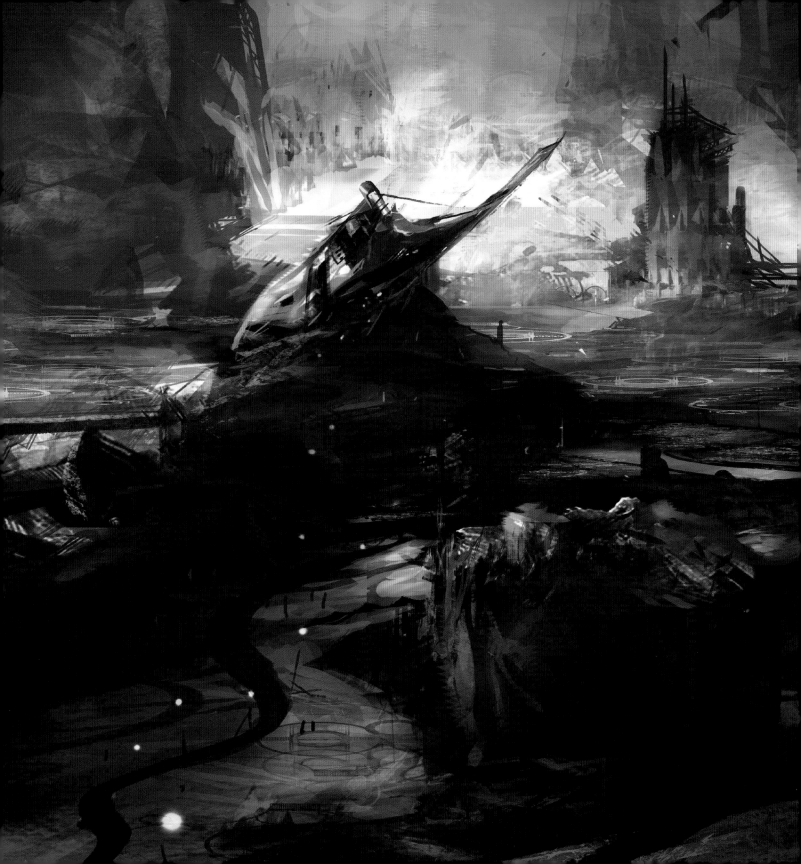

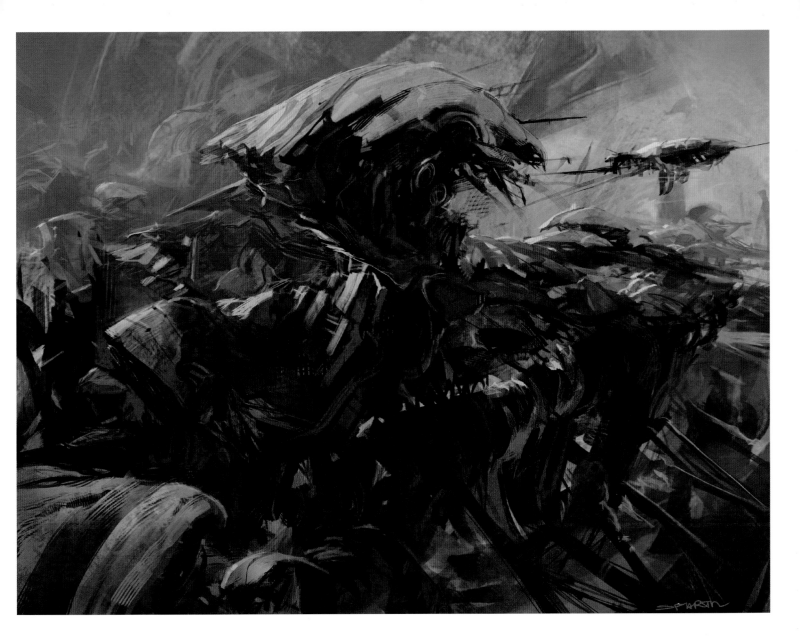

opposite page: Lopozides - 2007

Anj-Kilar - 2005

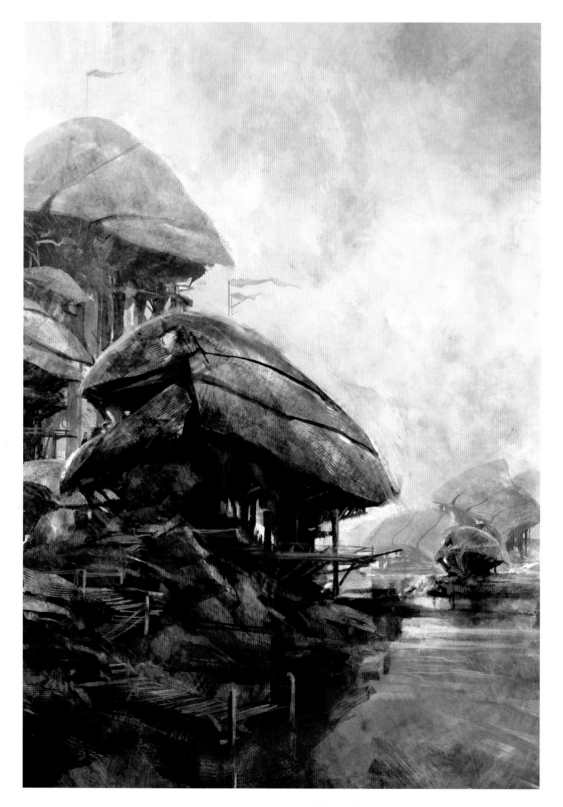

Avanty World - 2004

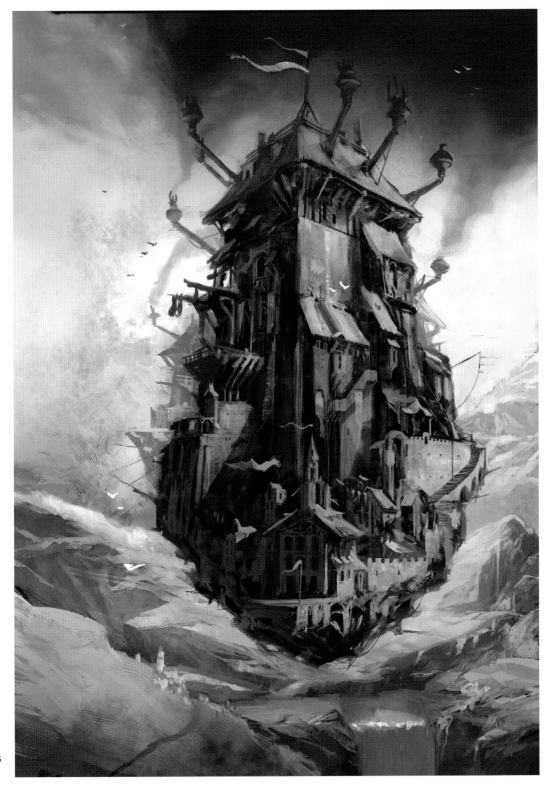

Howl's Moving Castle - Diana Wynne Jones
2005 - book cover

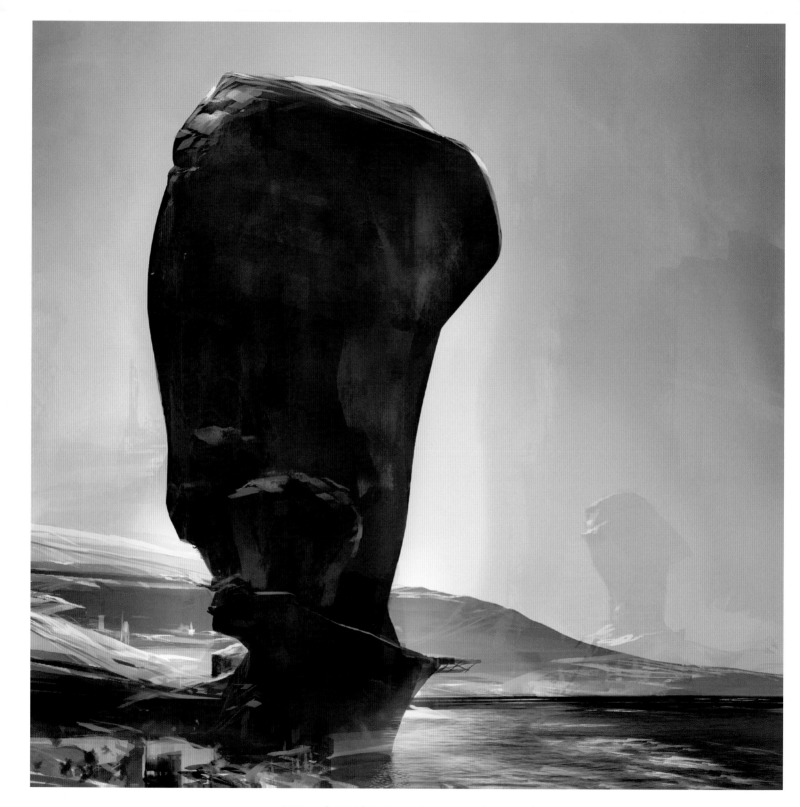

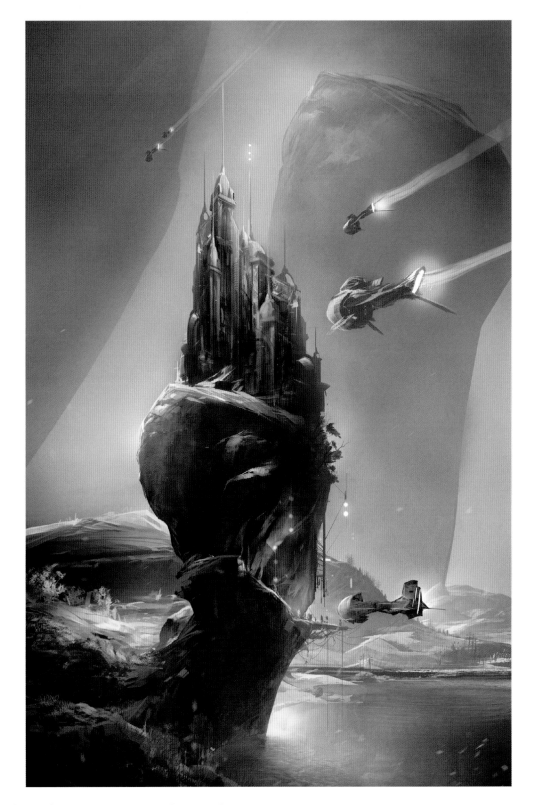

opposite page: Galactic Pot-Healer
initial sketch - book cover

Galactic Pot-Healer - Philip K Dick
2006 - book cover

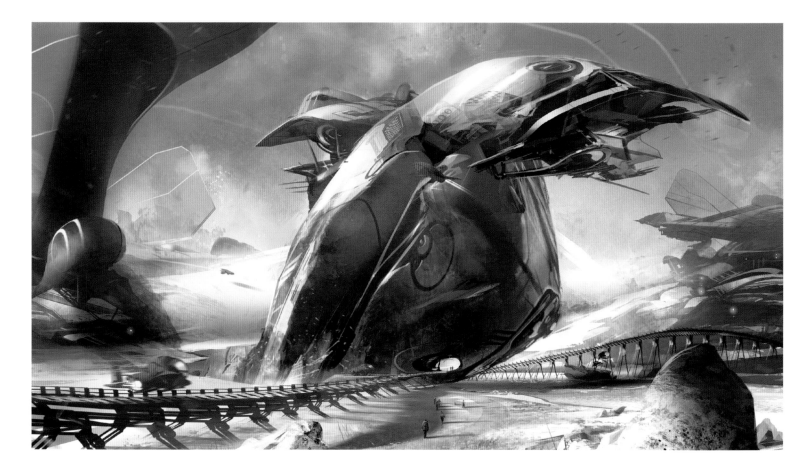

Monowin - 2006

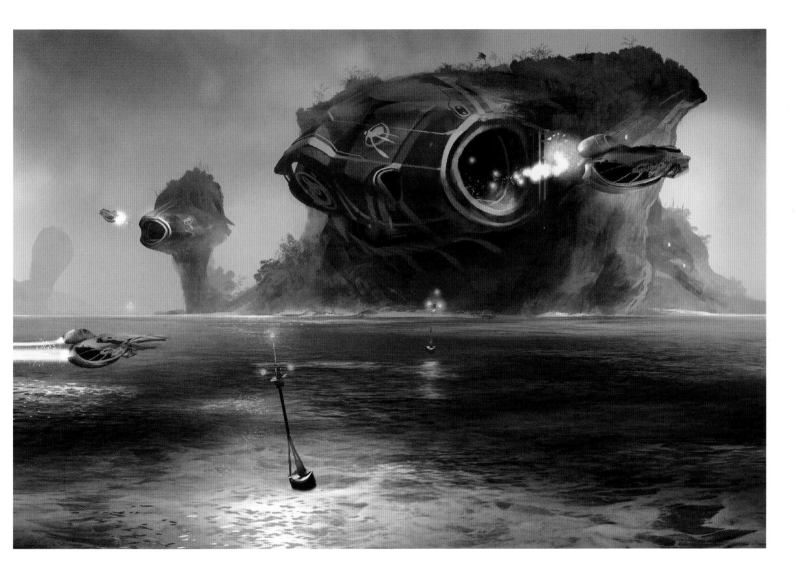

Premium Import - 2006

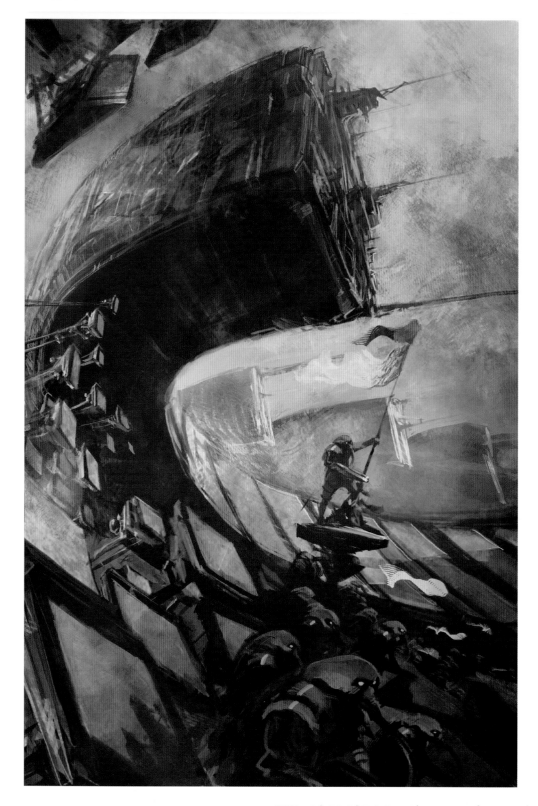

Delirium Screenies - preliminary sketch for
the Delirium Circus - 2005 - book cover

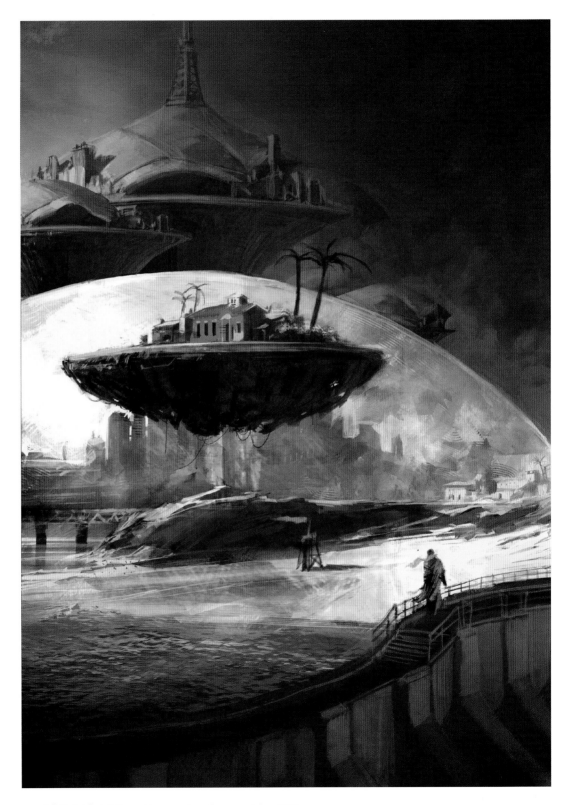

Delirium Circus - Pierre Pelot
2005 - book cover

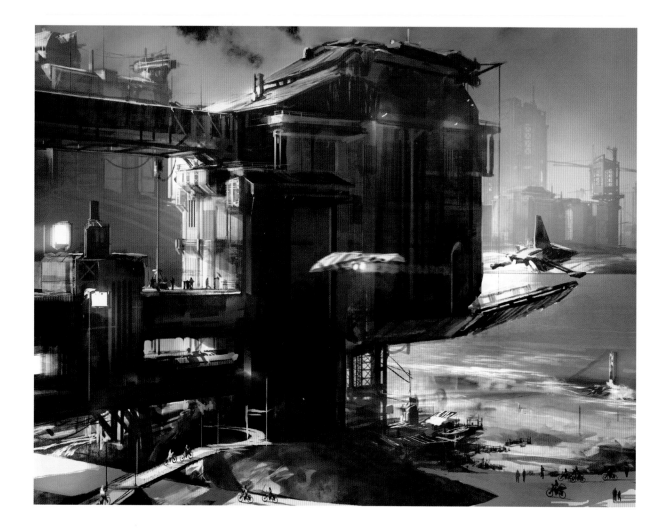

On the Road to Benvay - 2005

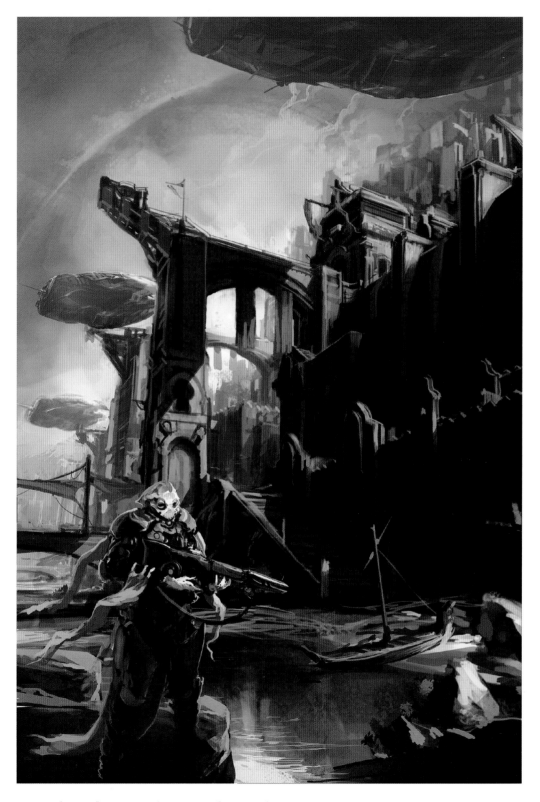

Emphyrio - Jack Vance
2004 - book cover

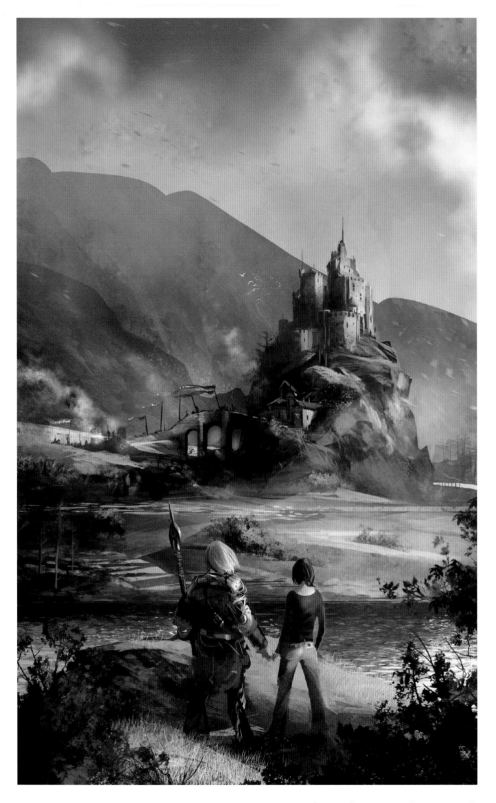

The Sterkarm Handshake - Susan Price
2006 - book cover

Within the Crust - initial sketch - 2006

Within the Crust - 2006

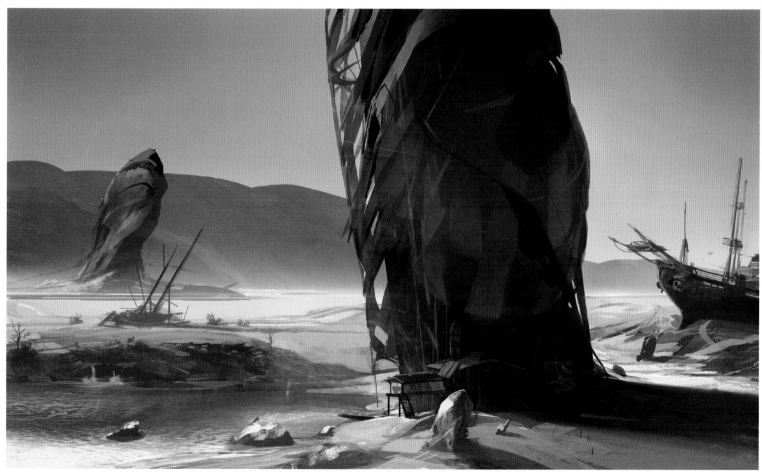

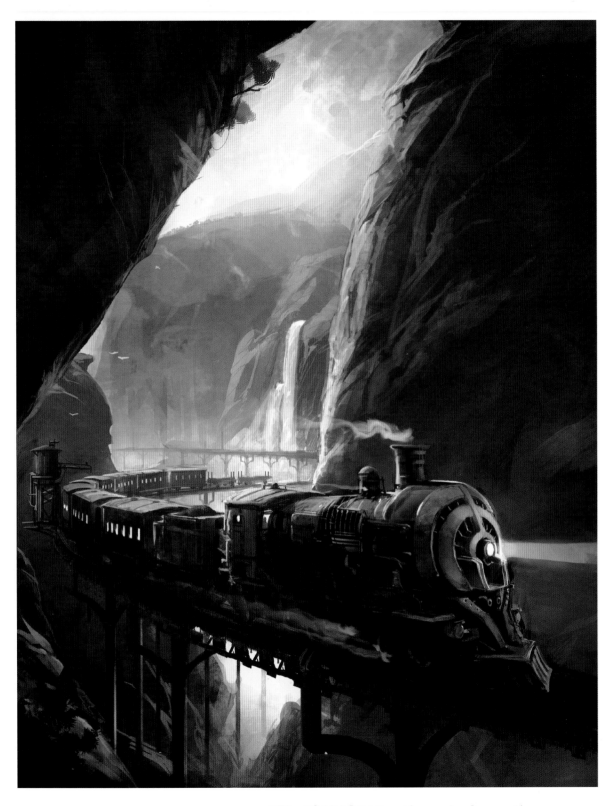

Les Continents Perdus
Thomas Day
2004 - book cover

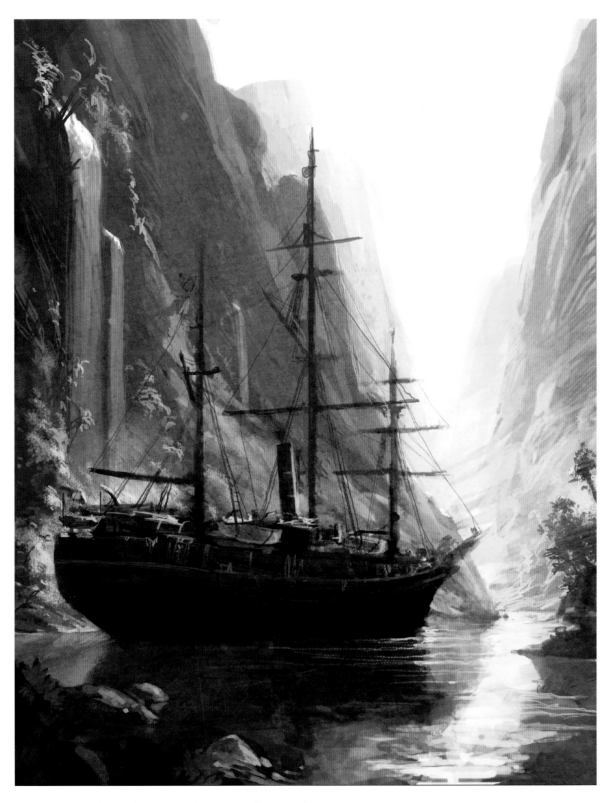

Darwinia
Robert Charles Wilson
2003 - book cover

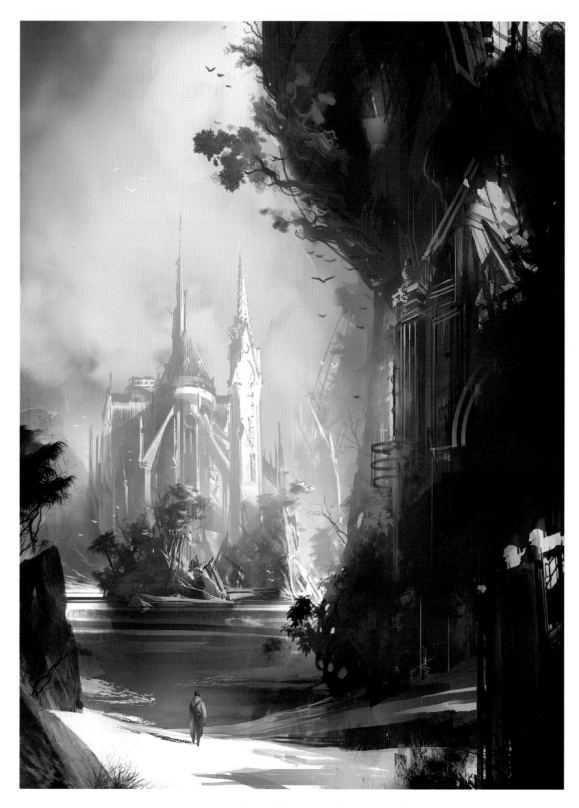

Le Monde Enfin
Jean-Pierre Andrevon
2006 - book cover

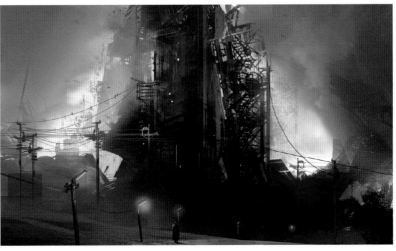

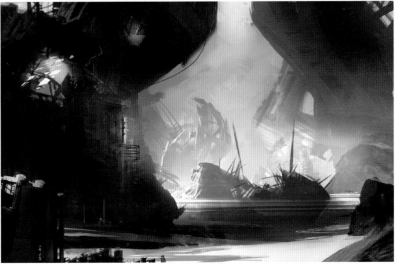

Le Monde Enfin - Jean-Pierre Andrevon
alternative sketches for
Le Monde Enfin - book cover

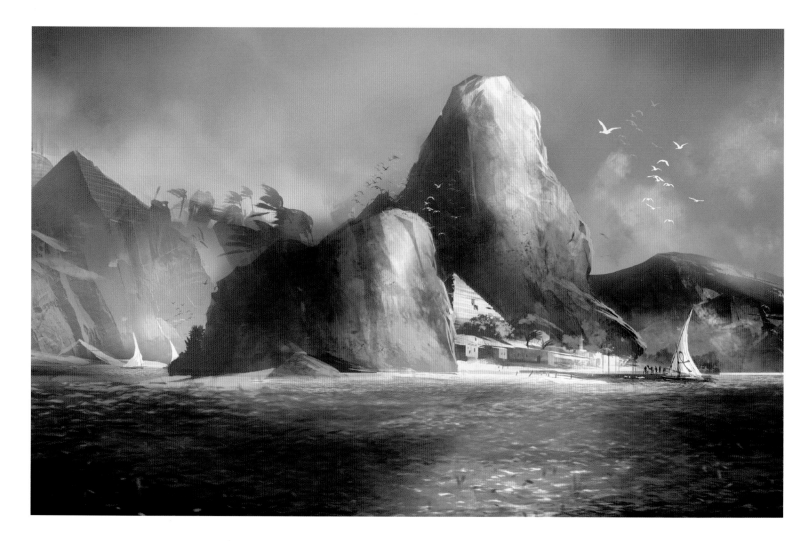

Mira's Island - 2006

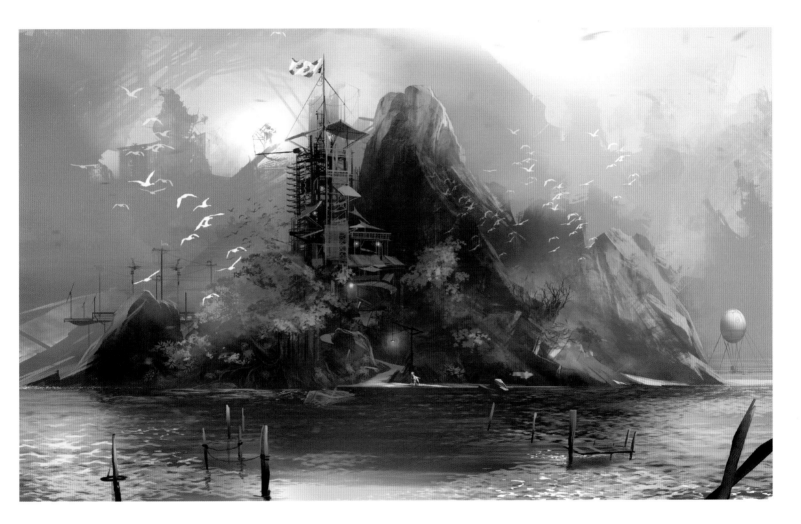

Dalmatians Island - 2006

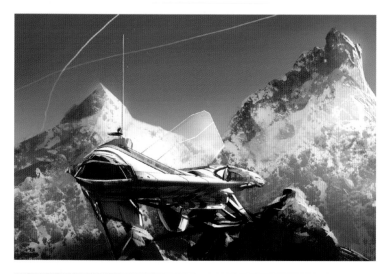

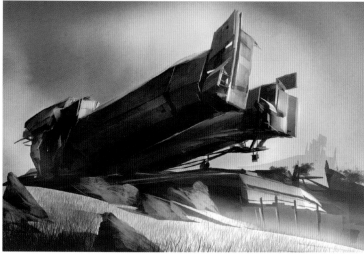

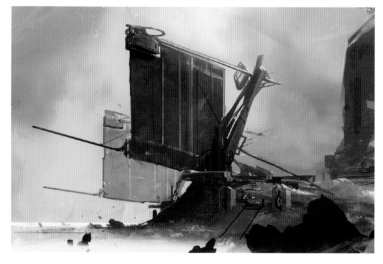

Archimount - 2007

The "U" - 2006

Wind Pannels - 2006

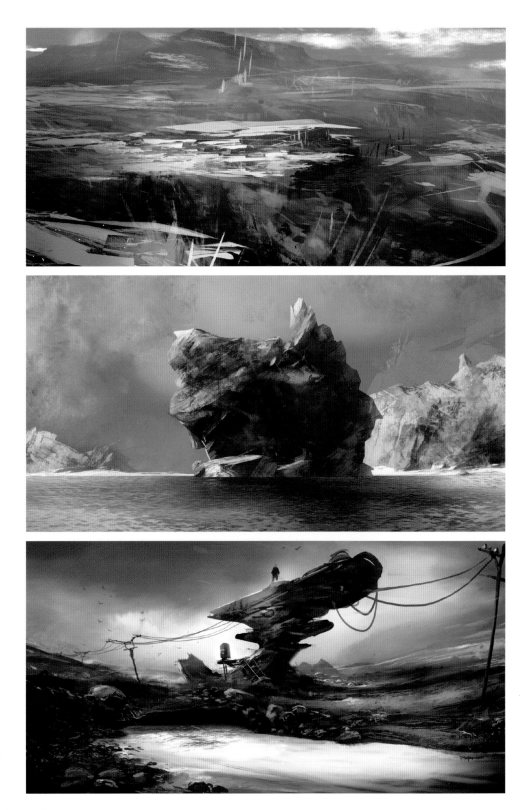

Vanarasi - 2005

Otori Tides - 2006

Rigoloroc - 2007

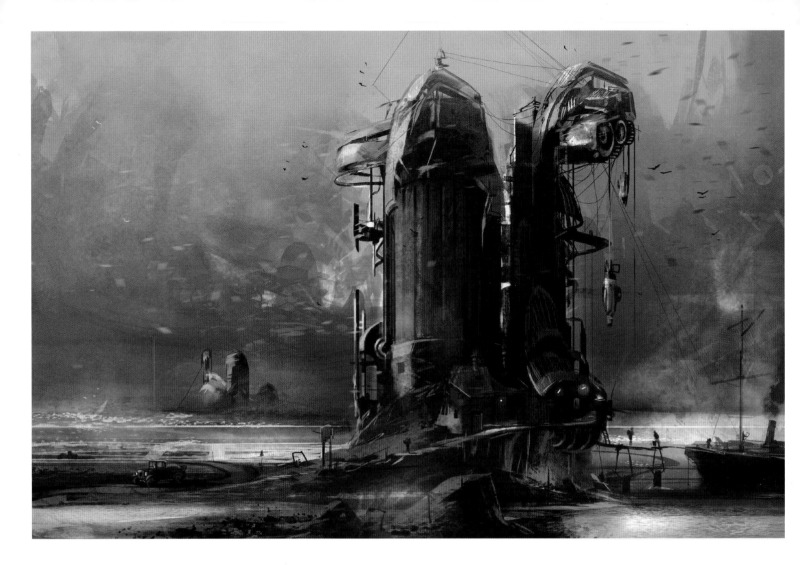

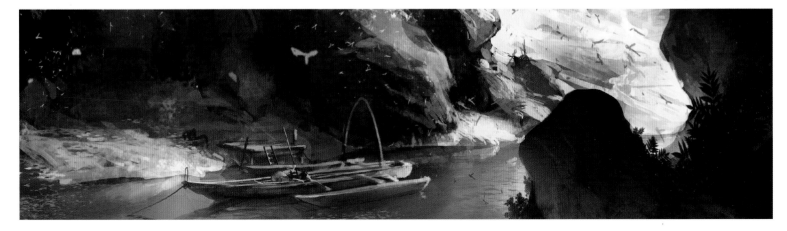

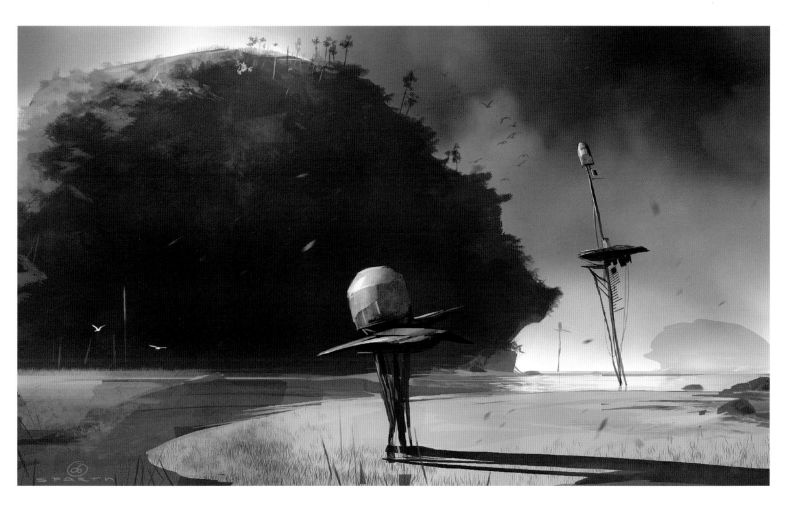

opposite page:

Red Sodium - 2005

Scene for Insects - 2005

Hundred Years - 2006

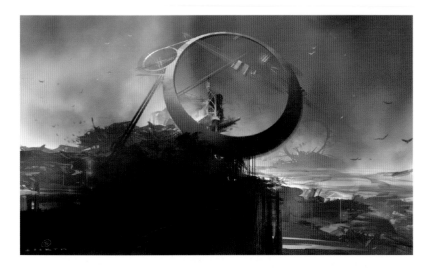

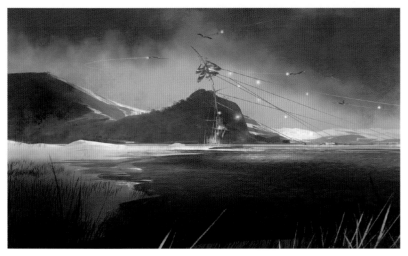

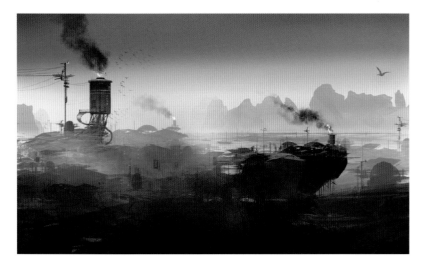

Dump Poetry - 2005

Dream State - 2006

Cheminees - 2006

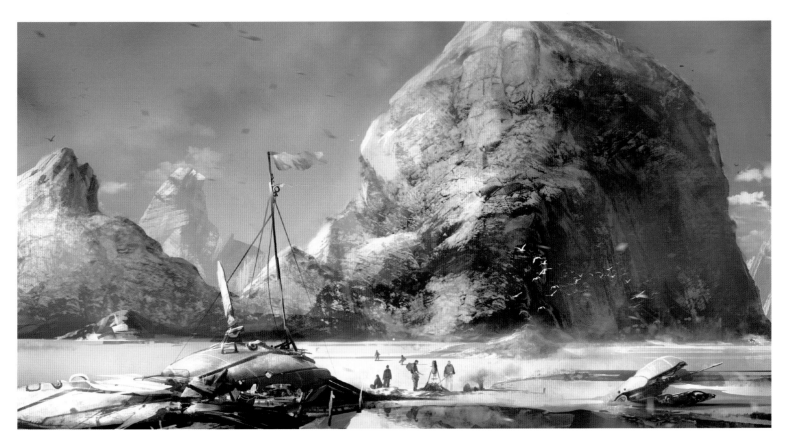

The Rescue - 2007

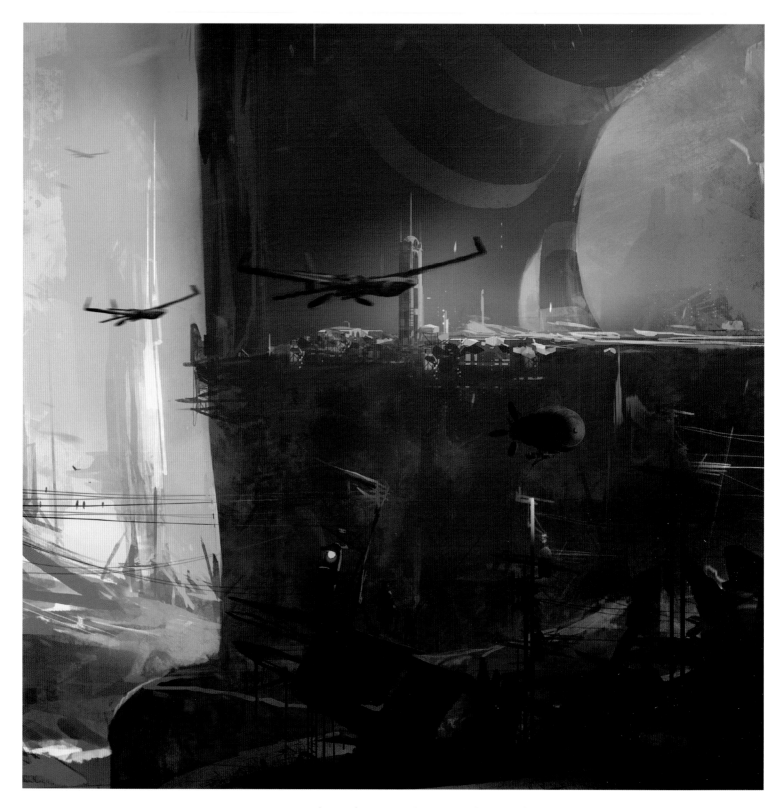

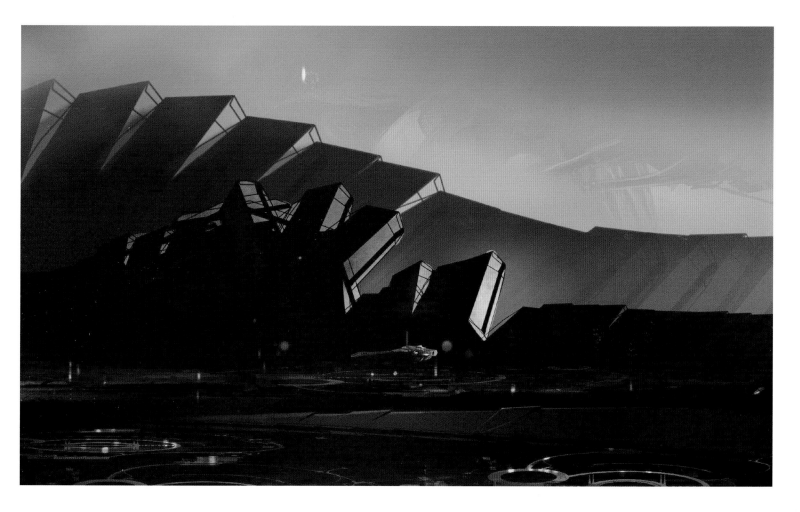

opposite page: Miniblimp - 2007

Richdig - 2007

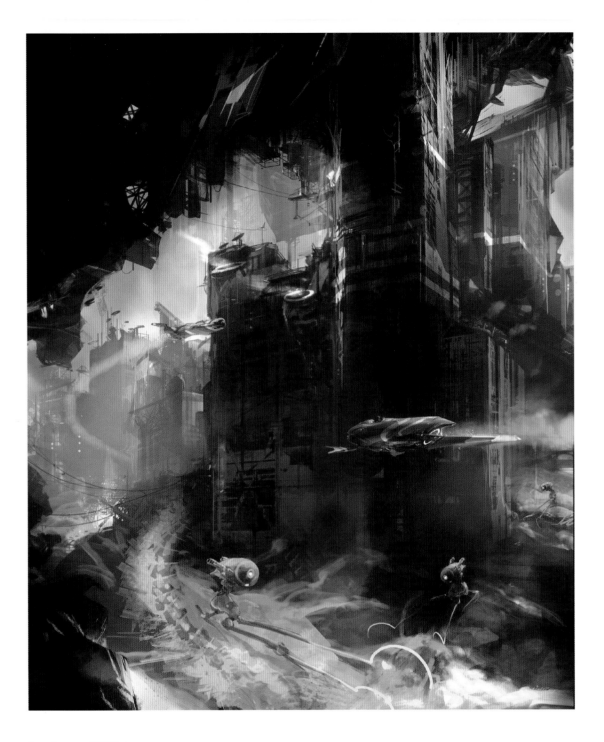

Low Larva - 2005

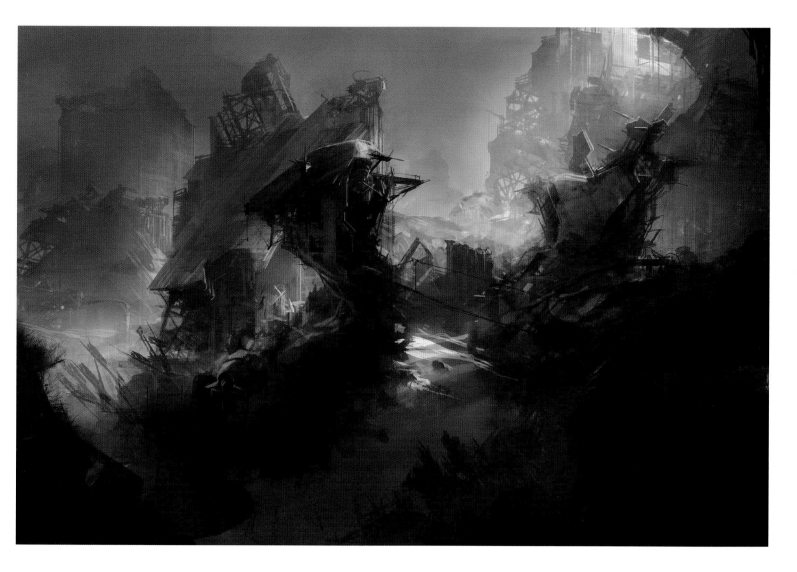

Decay - 2005

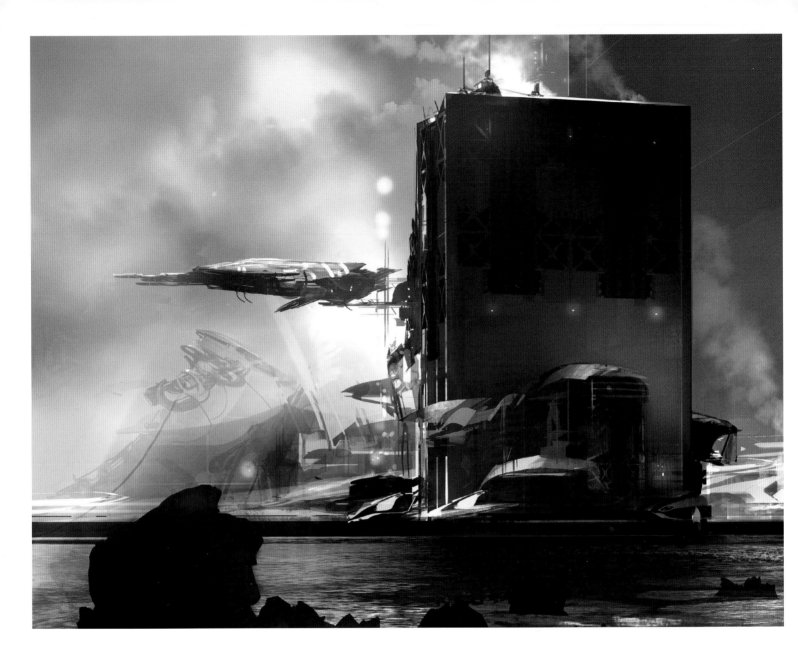

Monosquare - 2007

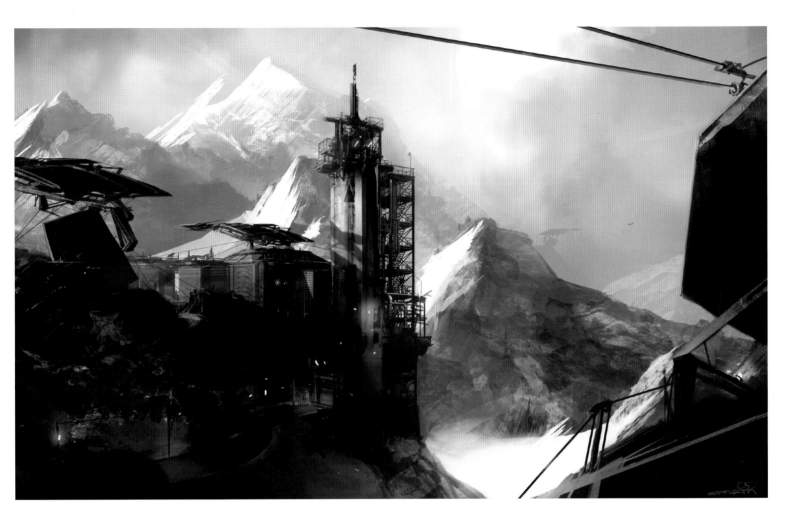

Bamon - 2005

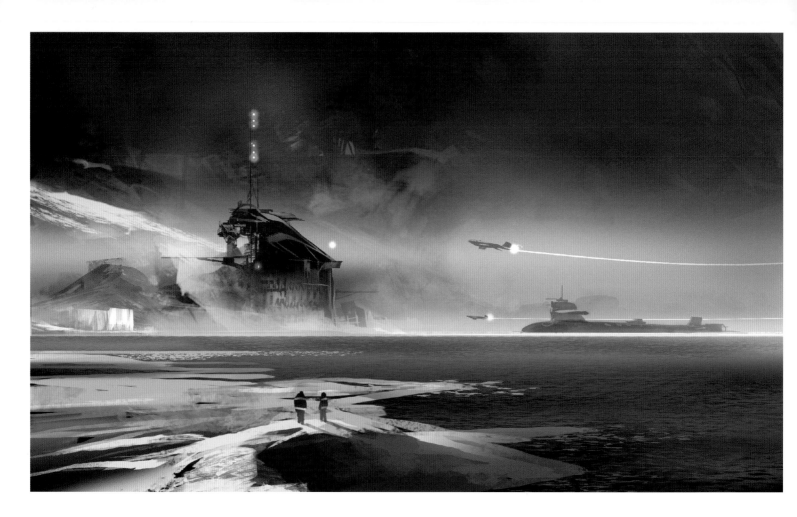

Returning to the Base - 2006

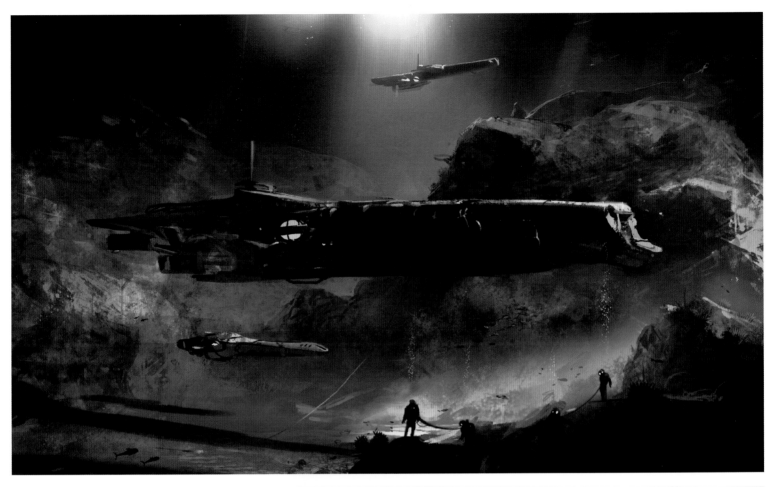

Sea Vertigo - 2007

Sea Vertigo - alternative sketch - 2007

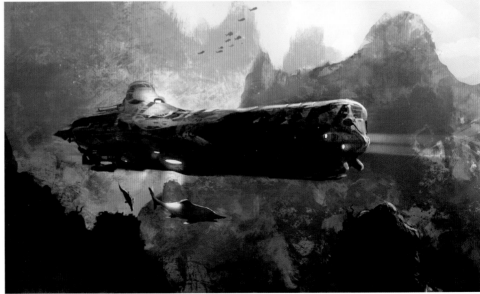

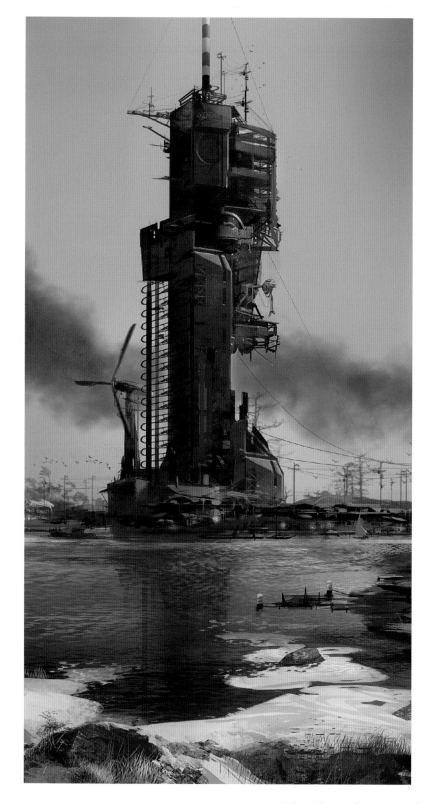

Dust Industry: close-up - 2006

Dust Industry - step 01 - 2006

Dust Industry - step 02 - 2006

Dust Industry - step 03 - 2006

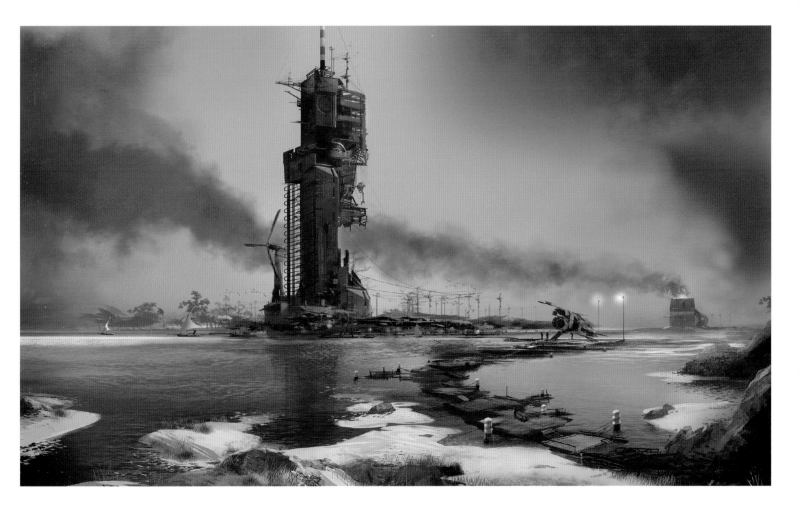

Dust Industry - 2006

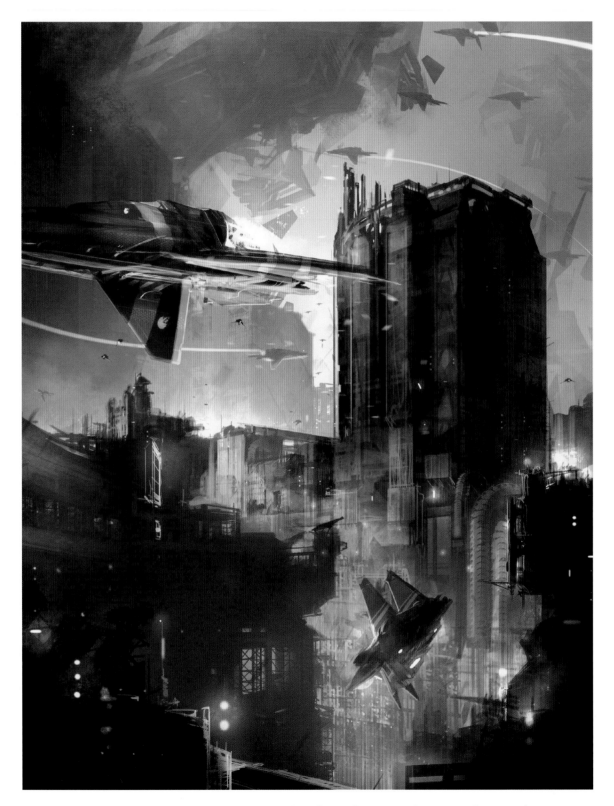

Tigers Off - 2005

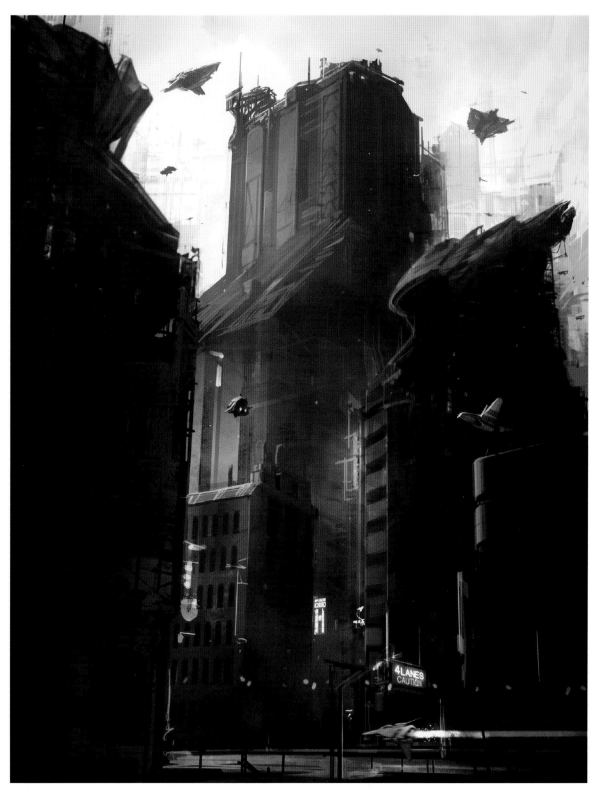

Lapsang Area - 2005

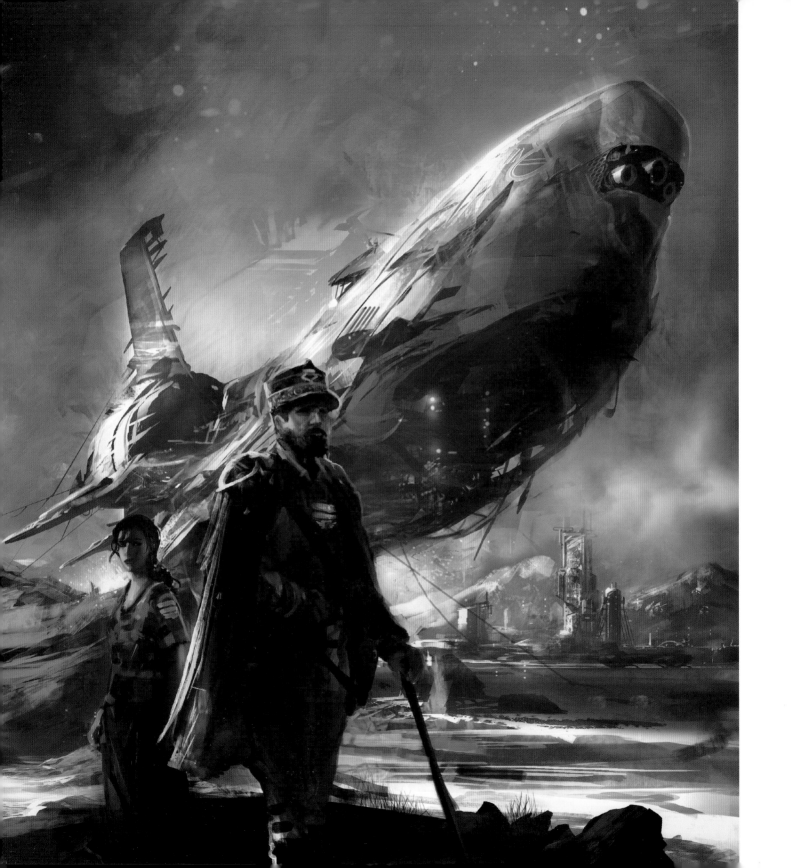

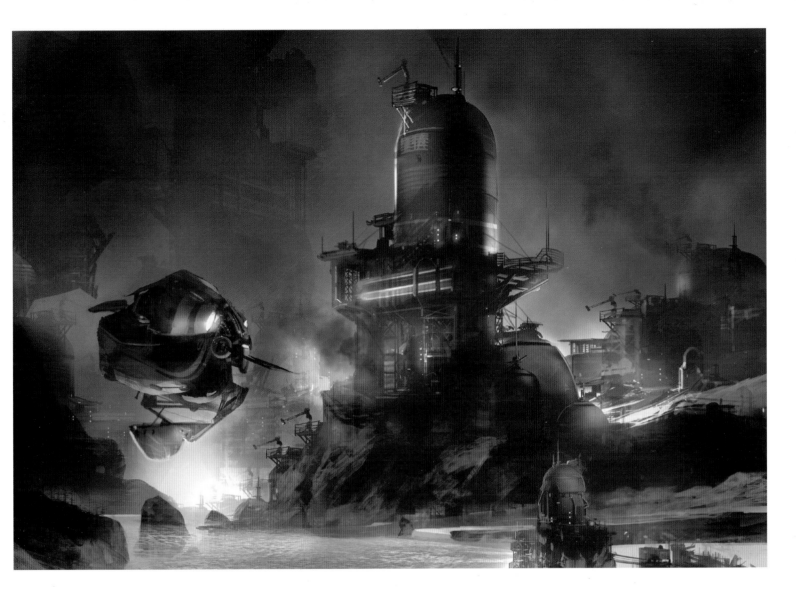

opposite page: The Martian General's Daughter
Theodore Judson - 2007 - book cover

Lava Industry - 2005

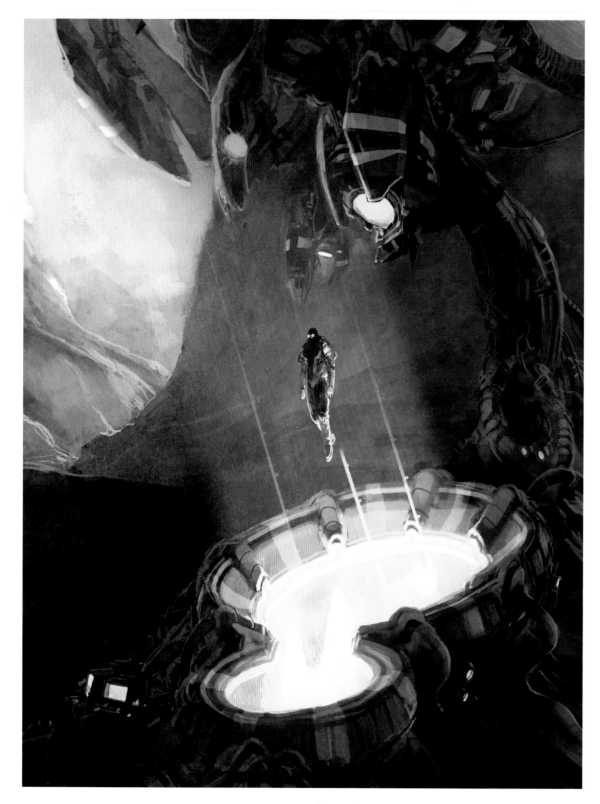

Time Opera
Robert Silverberg
2004 - book cover

opposite page: Non Stop
Brian Aldiss
2007 - book cover

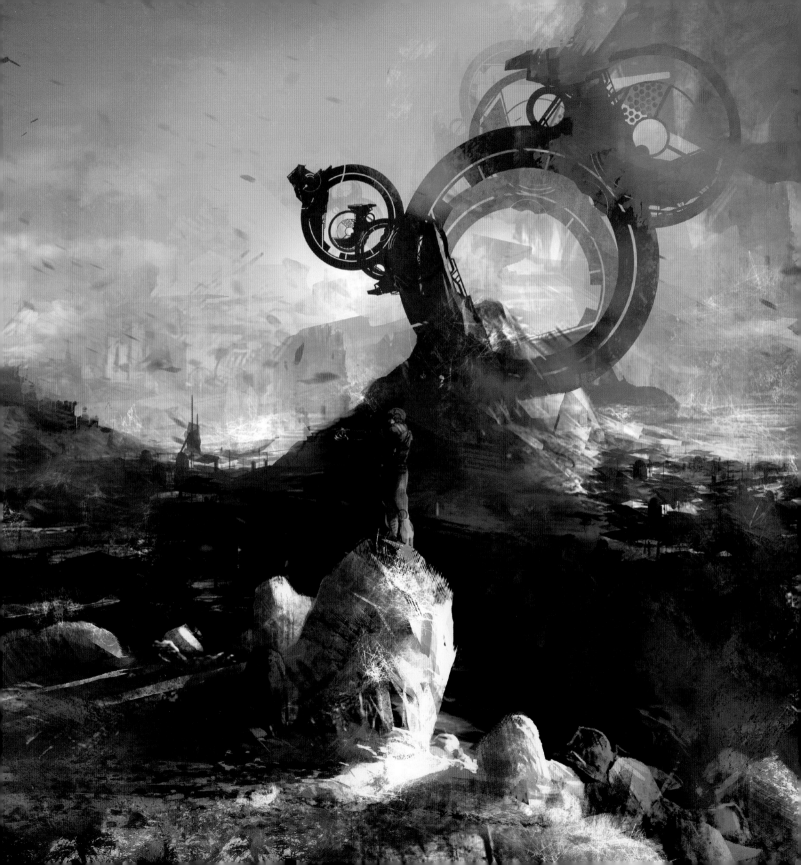

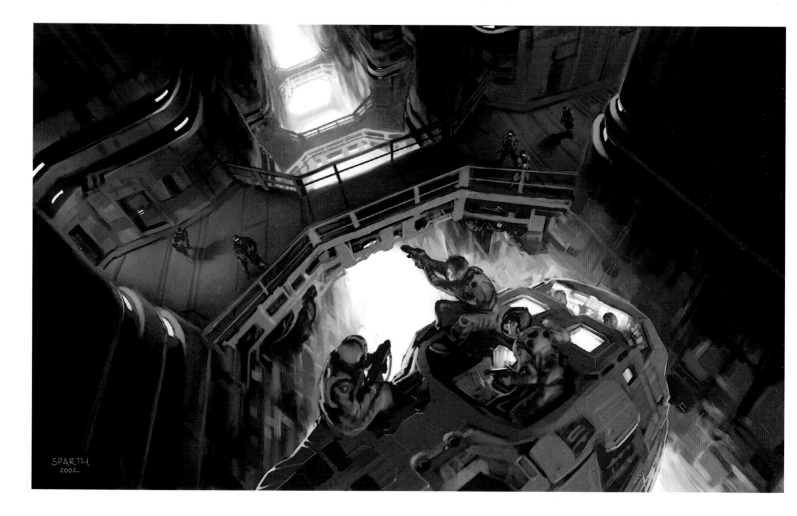

Confrontation - 2002

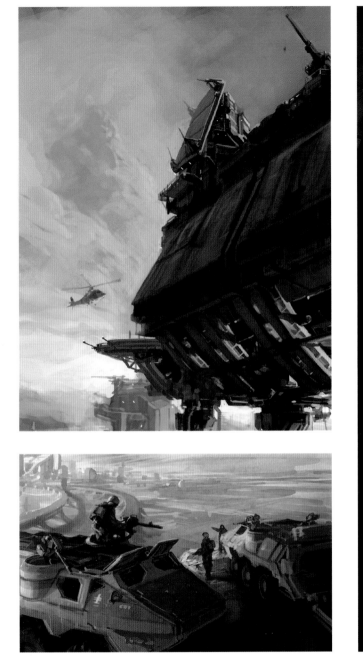

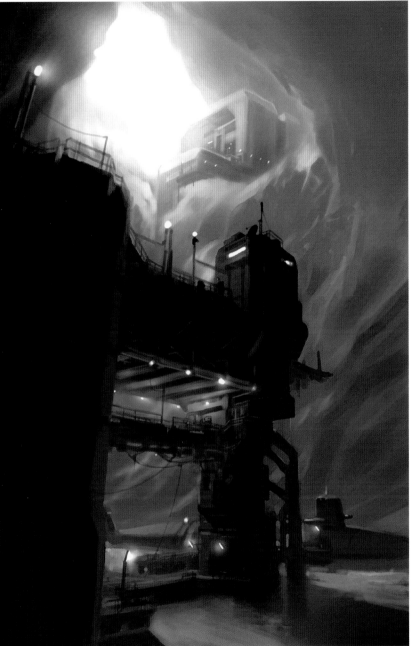

Sea Structure - 2003

Desert Squad - 2003

Hidden Industry - 2002

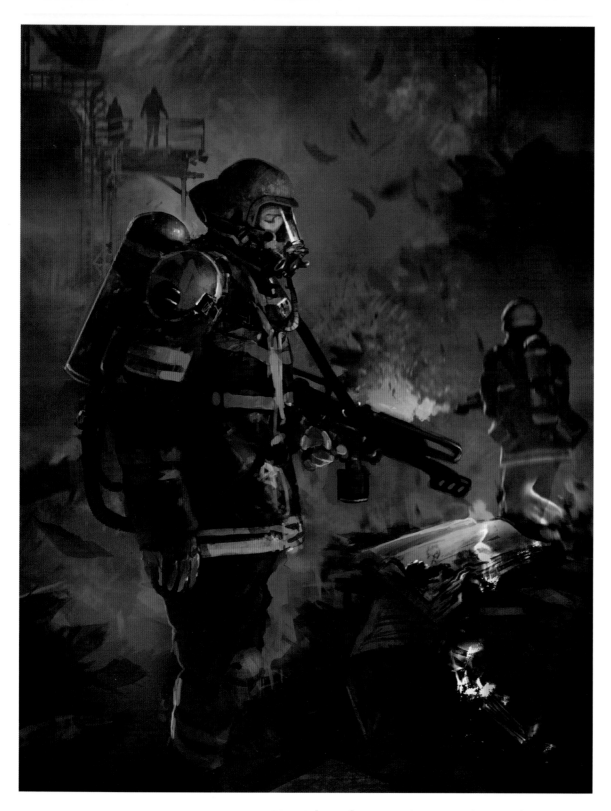

Fahrenheit 451 - Ray Bradbury
concept 1 - 2007 - book cover

Fahrenheit 451 - Ray Bradbury
concept 2 - 2007 - book cover

Fahrenheit 451 - Ray Bradbury
2007 - book cover

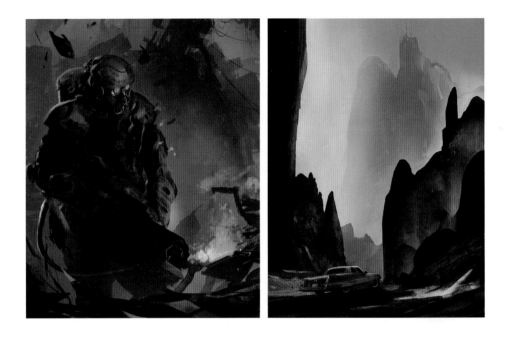

special thanks

My biggest thanks goes to all my close family and friends. It's because of you all that I became what I am today: My lovely wife, Lorene and my two sons Tutur and Leo. To my parents, who have always believed in me. To Virginie and Charles. To Manu and Eva, To Jacqueline and David, thanks to you I've seen so many rockets and shuttles take off. You're the ones who made me love what has become today my second country. To Bruno "hydropix" Gentile, maybe one day we'll go back in the blizzard together... or maybe not! David "vyle" Levy, we have always shared the same dreams my friend. Benjamin "ptitbenj" Carre, you're the one who brought me into digital art in the first place. Bengal and all our hilarious discussions. Mathieu Lauffray, for more than 15 years of art advice and a permanent friendship. Scott Robertson, and his ability to make dreams come to life. I will forever be grateful for your dedication and help.

All around France: Francois Baranger, David Demaret, Moket, Marc "Kemar" Simmoneti, Daniel Louvard, Patrick Pion, Xavier Dorison, Denis Bajram, The Cafesale Forum, Kness & M4de, Jean-Sebastien Rossbach aka "Livingrope", Aleksi, Laurent "Beet" Beauvallet, Bertrand "Coolber" Carduner, Thierry Desseault, Lucas Albert, Simon G.Phelipot, Jerzy Budzinsky, Benoit "Bal" Stordeur, Marc Botta, Yves Dalbiez, Kratul, Goron, Monique, Mirabelle, Laurent & Seb at Kando Games, Guillaume Gouraud, Antoine Villette, and the whole Darkworks Team. The Steambot crew: Thierry "barontieri" Doizon, Nicolas "Viag" Ferrand, Sebastien "Rainart" Larroude, Patrick Desgrenier, Joel aka "Feerik", Frederic "Frood" Jovet. Ubisoft MTL: Herve "Nuro" Groussin, Pat Lambert, Danny "Frost", Haejun and Max, Ulrick, Crapo and Isa, Fred and Delphine, Pascal Blanche, Salome Strappazon, Andrzej Tutaj, John Bigorgne. The Massive Black crew: Jason Manley, Andrew Jones, El Coro, Peter Konig, Oblio, Nox, Hpx, and of course everyone at Conceptart.org

ID software: Kenneth Scott, Andy Chang, Eric Webb, Seneca, Vitaliy Naymushin, Timothee "Ttimo" Besset, Patrick Duffy, Miss Donna the "ID mom", and the whole art team for their constant support. North America: The Sijun Forum, Mathias "m@" Verhasselt, Manny Carasco, Igor Alban Chevalier aka "the black frog", Travis Bourbeau, Dan Milligan, Mr Blonde, Sammy, Watmough, Daniel "Tinfoil" Dociu, Jaime Jones, Phil Holland, Jawn Lim, Jean-Eric Heneault, Mathieu Raynault, Raphael Lacoste, Dylan Cole, Craig Mullins, Jon Foster, Thom Tenery. Publishers and writers: Lou Anders, Nicole Lhote, Benedicte Lombardo, Gilles Dumay, Harry Allen "The Media Assassin", Jean-pierre Andrevon and Pierre Pelot.

And Finally, I am also forever grateful to all these great artists and musicians who have inspired me during all these years: Santiago Calatrava, John Berkey, John Harris, Ridley Scott, George Lucas, Stanley Kubrick, Sergio Leone, Ralph McQuarrie, Hayao Miyazaki, Bruce Pennington, Stephan Martiniere, Neil Campbell Ross, Hans Bacher, Mike Mignola, Masamune Shirow, Biosphere, Vangelis, Philip Glass, John Barry, Wojciek Kilar, Ennio Morricone, John Williams, and Jerry Goldsmith, to name just a few....

Thanks to all the ones I could have forgotten in this list.
You know who you are.